Publish Your Photography Book

Publish Your Photography Book

Darius D. Himes & Mary Virginia Swanson

———

Princeton Architectural Press, New York

Published by
Princeton Architectural Press
37 East Seventh Street
New York, New York 10003

For a free catalog of books, call 1.800.722.6657.
Visit our website at www.papress.com.

Editor: Linda Lee
Designers: David Chickey, Masumi Shibata
Photography: Darius D. Himes, Masumi Shibata

Special thanks to: Bree Anne Apperley, Sara Bader, Nicola Bednarek Brower, Janet Behning, Megan Carey, Becca
Casbon, Carina Cha, Thomas Cho, Penny (Yuen Pik) Chu, Russell Fernandez, Pete Fitzpatrick, Jan Haux, John
Myers, Katharine Myers, Dan Simon, Andrew Stepanian, Jennifer Thompson, Paul Wagner, Joseph Weston, and
Deb Wood of Princeton Architectural Press—Kevin C. Lippert, publisher

Library of Congress Cataloging-in-Publication Data
Himes, Darius.
Publish your photography book / Darius Himes and Mary Virginia Swanson. — 1st ed.
 p. cm.
ISBN 978-1-56898-883-2 (alk. paper)
1. Photobooks—Publishing. 2. Photobooks—Publishing—United States.
I. Swanson, Mary Virginia. II. Title.
Z286.P47H56 2010
 070.5—dc22
 2010024162

Contents

Introduction

PHOTOGRAPHY BOOKS HAVE NEVER COMMANDED GREATER INTEREST THAN they do today. Over the past fifteen years, interest in photography books has grown at an accelerated rate, due in no small part to the welcoming embrace of photography by the contemporary art world. Each year, hundreds are published worldwide, collected and hunted down by the obsessed—many sold at triple and quadruple their original retail value. They provide an artist a passport to the international photography scene; exhibitions, talks, gallery walks, book signings, and press interviews are all brought into being through their publication. Both the supply and the demand seem to be increasing.

In this atmosphere, the opportunities for publishing a book of one's photographs have never been more plentiful. Now more than ever, both aspiring artists and established professional photographers ask, "How do I get my project to a publisher?"

With the publishing field constantly expanding, the need for a guide to answer that question and to point out the various avenues to pursue and pitfalls to avoid is obvious. *Publish Your Photography Book* is written with photographers in mind. Its sole aim is to crack open the door to the publishing world and lead the reader through an exploration of this rich sphere.

The book is assembled into six sections. The first section, "The Photography Book Phenomenon," initiates the reader to the history of photography book publishing. From the early 1990s to the present, there has been a burgeoning number of publishers, particularly small art publishers, on the international scene, while at the same time technological developments have placed more and more tools for bookmaking directly into the hands of artists and photographers. This two-fold growth in the field has been coupled with an

academic interest in the history of the photography book, and the confluence of these trends has led to a renaissance in the medium.

The second section, "The Nuts and Bolts of Publishing," provides an overview of the publishing industry. Regardless of whether you intend to self-publish—making a book by hand, contracting parts out to various specialists, or utilizing print-on-demand (POD) technology—or are seeking a trade-book publisher, this section reveals how publishers think and the decisions they make in taking on a photography book.

The third and fourth sections, "The Making of Your Book" and "The Marketing of Your Book," respectively, look closely at the actual process of making and then marketing a book of photographs. Every stage is covered in detail, including the conceptualization of a book and delineation of the editorial content, the design and production process, and finally the creation of a comprehensive marketing strategy, which covers what to do leading up to and just after the official launch of the book.

"Case Studies," the fifth section, is built around discussions and interviews with published photographers from across the spectrum of the photography world. There is nothing more informative than learning from real-life examples.

The sixth, and last, section, "Resources, Appendices, and Worksheets," contains a wealth of resources and information to aid in your understanding of the publishing industry and in preparing your work for publication. Here you will find lists of independent bookstores, publisher submission requirements, author questionnaire forms, sample timelines, and other publishing industry and book arts resources designed to aid you in moving forward toward a book of your photographs.

Throughout the book, numerous examples of published photography books illustrate the diversity within the field. The range of approaches to a well-conceived and well-crafted book of photography is virtually unlimited, and photographers of all types have expanded our horizons through their creativity and engagement.

Ultimately, this book is about our inherent desire to communicate, about creating and manifesting one's creative vision in book form. Photographs can be disseminated in many ways, but as a book it has a lasting appeal to a very wide audience. *Publish Your Photography Book* speaks to, and with, all the readers, designers, publishers, typographers, and, of course, the photographers who have ever wished to see a book of their photographs out in the world.

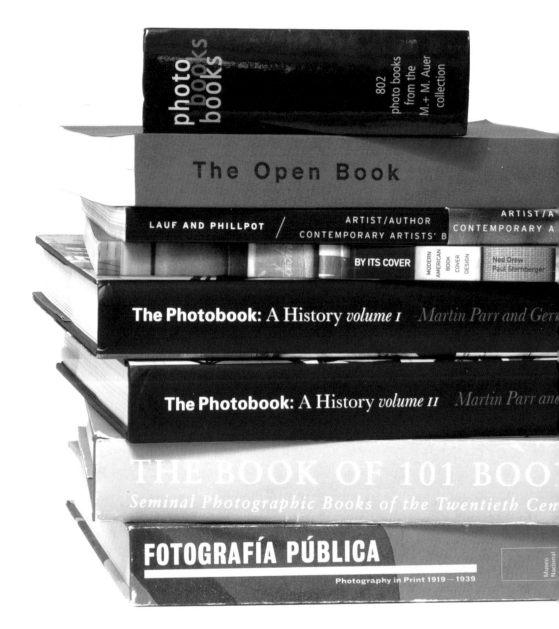

photo books books

802 photo books from the M. + M. Auer collection

The Open Book

LAUF AND PHILLPOT / ARTIST/AUTHOR CONTEMPORARY ARTISTS' B

ARTIST/A CONTEMPORARY A

BY ITS COVER

MODERN AMERICAN BOOK COVER DESIGN

Ned Drew Paul Sternberger

The Photobook: A History *volume I* *Martin Parr and Gerr*

The Photobook: A History *volume II* *Martin Parr and*

THE BOOK OF 101 BOO

Seminal Photographic Books of the Twentieth Cen

FOTOGRAFÍA PÚBLICA

Photography in Print 1919—1939

Museo Nacional

1

The Photography Book Phenomenon

Who Cares About Books? Photographers Do.

TALK TO ANYONE WHO HAS BEEN INVOLVED IN THE PHOTOGRAPHY WORLD OVER the last ten to fifteen years, and they will affirm that the photography book market has exploded. The late author and critic Bill Jay exclaimed some years ago: "When I began my career in photography, it was easy to acquire every photographic book of consequence because they were published at the rate of one every six months!"[1] Now there are literally hundreds of books published and hundreds more submitted to publishers annually. Never before has there been such widespread interest in the printed image.

Corresponding to this upsurge in publishing activity, and surely contributing to its cause, is the fact that more students and artists are choosing photography as a primary mode of artistic expression, with the book as the desired end result. The bald statement "I want a book of my photographs" is on the lips of nearly every photographer, but only a few have more than a tentative grasp of the component parts of a book, an understanding of what they want to express and how they want to express it, or why this body of work needs to be seen in book form as opposed to on the gallery wall or in a magazine.

In our personal lives, both photographs and books are often burdened with sentimental value, becoming loaded symbols of our private histories and complex social relationships. (Who doesn't have snapshots and pressed petals and notes from former lovers scattered throughout their own personal collection of books?) Throughout the history of photography, photographic images and text have been combined together in book form, and recent scholarly attention to the *book* component of photographic history has fueled this boom in photography-book publishing, creating a lasting impact on contemporary photographic practice.

As people who talk with photographers and publishers on a regular basis, we're often asked if we think that books will slowly be replaced or fade into cultural history. "What about the Internet?" many worry out loud. "Do you think that printed books will disappear?"

The short answer is no, not a chance. Books are conveyors of ideas, mementos of civilization, and harbingers of change. As the late historian Barbara W. Tuchman wrote, "Without books, history is silent, literature dumb, science crippled, thought and speculation at a standstill. Without books, the development of civilization would have been impossible."[2]

Books, as physical objects, are indispensable to our collective history, and they are indelibly printed onto our consciousness from early on. If you can point out just one five-year-old who has a favorite PDF instead of a favorite bedtime book, then perhaps books, made of paper and ink, will disappear. What children intuitively and instinctively know is that the very materiality of a book is half of the joy of any reading experience. The story, of course, comprises the other half.

And while the sensual experience of holding a MacBook Air borders on the rapturous, it still does not convey the sensuality of a beautifully printed art book (even if it is something to use to send an email telling of your newest book from Steidl). In general, books are talismans for the modern woman and man, and we form nearly permanent bonds with them as teenagers and adults. They are the security blankets and teddy bears of the adult world. Many of us cart our books from state to state, from college dorm to rented apartment to newly purchased home, and lovingly set them up on our shelves as reminders of knowledge acquired and courses and degrees completed, and as familiar companions.

There is a long and storied history of scribes and manuscripts, of printing presses and the bookmaking craft that is outside the purview of our book. The desire and ability to create written languages is uniquely human, and whole civilizations have been built around and because of them. (See, for example, Steven Pinker's books, particularly *The Language Instinct: How the Mind Creates Language* [William Morrow and Company, 1994]). The very notion of a "written language" implies a material upon which words are recorded, and a brief scan reveals all sorts of variations on this theme—tablets, stelae, scrolls, screens, accordion papers, bags of inscribed bones, hinged wood panels, and, of course, sheets of paper bound with thread, all of which dot the history of humankind's desire to record and convey the written word. It was the fifteenth-century printer Johannes Gutenberg's invention of movable type that propelled humanity into a new era, one of ever-increasing facility in reproducing the written word.

Travel forward to the twenty-first century, and there are all sorts of additional ways that written language is conveyed. The primary advancement is in electronic media, both audio and visual. But as to the act and effect of reading the Psalms? Hand-drawn calligraphy on a sheet of vellum from the twelfth century is essentially no different than reading the same on a Kindle from Amazon; they are both physical objects upon which one can read the written word. The powerful digital tools that are now at our disposal have heightened our ability to disseminate our text and images.

But of all the histories of visual and plastic arts, that of photography has a special place for the book. Most photographers, curators, and gallerists (especially those of a certain age) learned of, and fell in love with, photography through books.

A book is all at once a seed, a tree, an orchard, a fruit, and then, again a seed…

Frish Brandt director, Fraenkel Gallery

———

Ultimately, books are far more accessible than exhibitions of important work. And while photographs are now readily accessible online, one can return to physical books repeatedly and absorb the accompanying texts at will—a lap, a few hours, and some sunlight are all that is required.

Since the dawn of the medium, photography has been intimately associated with the book form. A ready example is the fact that when scientist and inventor William Henry Fox Talbot discovered that salts of silver were sensitive to light, he began recording the outline of various objects in his home and studio and published these initial experiments in booklet form. For a small fee, one could subscribe to *The Pencil of Nature* (Longman, Brown, Green & Longmans, 1844–1846), receiving through the mail on a quarterly basis an unbound folio with a smattering of new "sun prints." It was common to have them bound once the series was complete.[3]

Photography was the perfect invention for a mechanized New World. If the industrial revolution produced a new body for humanity—with machines acting like so many limbs and organs, and speed, at an ever-increasing rate, playing its role as the blood of this new corpus—then photography was its eye.[4] The invention provided a new way to see the world—further, deeper, smaller, bigger, faster, and slower than waking experiences could provide. All manner of phenomena were scrutinized under this new panopticon (as were long-held ideas and stereotypes), all of which were printed and disseminated through books.

We have reached a threshold where the history of the photography book has now entered into the realm of scholarly study. Art-history courses at both the graduate and undergraduate level draw as much on photography books as they do

Henri Cartier-Bresson, *The Decisive Moment*
(as featured in *The Photobook: A History*, volume one, Phaidon, 2004)

Underpinning our mission is the belief that books provide an indispensable foundation for comprehending and caring for the places where we live, work, and commune.

George Thompson founder, Center for American Places

————

on individual images. This history of the photography book is, as photography historian Shelley Rice has written, "a secret history embedded within the well-known chronologies of photographic history."[5] This newly born discipline is being fueled in no small part by a rather tiny cluster of books, all published in the last ten years.[6] The first was *Fotografía Pública: Photography in Print from 1919–1939* (Museo Nacional de Arte, 1999). Edited by Horacio Fernandez, this volume was the first to look at the years immediately following World War I, during which offset lithography became the predominant method for reproducing photographs on the printed page, a norm that persists today. The very title of the book, translated as "public photography," hints at the availability and, on a certain level and in certain cases, the popularity that these volumes achieved in the public arena.

Fernandez is also keen to present the book as object: by showing us facsimile reproductions of each book's cover and at least one interior spread, the reader gets a real sense of their designs and proportions—in short, the materiality of the book. Organized alphabetically by artist, *Fotografía Pública* includes many of the books that we now consider to be classics of photography: *Paris by Night* by Brassaï (Editions Arts et Metiers Graphiques, 1933), *An American Exodus: A Record of Human Erosion* by Dorothea Lange (Reynal & Hitchcock, 1939), and *Paris* by Moi Ver (Editions Jeanne Walter, 1931).

What *Fotografía Pública* established—complete bibliographic and publication information, facsimile reproductions, capsule reviews about the historical importance of the artist and publication—Andrew Roth's *The Book of 101 Books: Seminal Photographic Books of the Twentieth Century* (PPP Editions, 2001) refined. Roth is a rare-book collector and dealer, as well as a publisher himself (he releases titles under

the PPP Editions imprint). As is made clear by the subtitle to his book, Roth set out to celebrate the close of the century with a tome that truly glorifies the history of photography books, placing equal emphasis on the importance of the photographic work as well as the craft and uniqueness of the book as object.

To those ends, Roth commissioned essays and reviews by many key figures in contemporary photography: Daido Moriyama, Jeffrey Fraenkel, Shelley Rice, Vince Aletti, and David Levi Strauss. Roth makes no bones about the list being a personal, and therefore highly selective, one. After all, it's a list of only 101 books. In a succinct introduction, he himself outlines the characteristics that make a great photography book:

> *The basis for my selection was simple. Foremost, a book had to be a thoroughly considered production; the content, the mise-en-page, choice of paper stock, reproduction quality, text, typeface, binding, jacket design, scale—all of these elements had to blend together to fit naturally within the whole. Each publication had to embody originality and, ultimately, be a thing of beauty, a work of art. Secondary was my concern for the specific photographer or the historical significance and impact of the work. In all but a few instances, I have focused on monographs that the artists had an active role in producing. I was also generally drawn to publications in which the photographs were meant to be seen in book form. In other words, not books that are merely a place to exhibit images but books whose images were destined to be seen printed in ink and bound between covers.*[7]

*A great book has outstanding photographs that have something new to say, with appropri-
ate production and design that allow the message to be discovered easily by the viewer.*

Martin Parr photographer and bibliophile

———

The effect that Roth's book had in the worldwide photography community
was phenomenal. It was loved, debated, ridiculed, and acclaimed. In short, it got
people talking. His list was both praised and criticized: certain collectors consulted
The Book of 101 Books as they would a shopping list, others deemed it far too per-
sonal and limited in scope, while the rest of us saw the volume as a crash course in
the history of twentieth-century photography, with Rice, Aletti, and Levi Strauss as
personal tutors.

It also spurred Martin Parr, the well-known British photographer and avid
photography book collector, to contribute to the then-raging dialogue. After the
publication of *The Book of 101 Books*, Parr immediately began work on what would
be a two-volume set coauthored with photo-historian Gerry Badger. Volumes one
and two of *The Photobook: A History* were published by Phaidon in 2004 and 2006,
respectively.

What Parr and Badger elucidate is the notion of a photography book as
something that is above and beyond a mere set of bound pages and a bunch of
CMYK-printed pictures. It is the marriage of the two that matters to them. In the
introduction to volume one, they quote Dutch historian Ralph Prins in order to
clarify their approach: "A photobook is an autonomous art form, comparable with
a piece of sculpture, a play or a film. The photographs lose their own photographic
character as things 'in themselves' and become parts, translated into printing ink, of
a dramatic event called a book."[8]

At this level, the book becomes something more than the sum of its parts.
But those parts are wildly multitudinous: paper, printing, binding, cloth, boards,
ink, typefaces and lettering, page layouts, sequencing and editing, trim size and

Alessandro Bertoletti, *Books of Nudes* [1]
(Harry N. Abrams, 2007)

proportion, essays and interviews, forewords and afterwords, bibliographies, captions, collections and exhibition chronologies, and, last but not least, the photographs themselves and their subject matter.

Where Roth had refined the presentation of books over that of *Fotografia Pública* (and deeply supplemented *The Book of 101 Books* with a wide range of critical and personal texts), Parr and Badger essentially expanded the purview of the subject and gave it a firm historical footing, creating a master list of books based on a strict and well-argued set of criteria that spanned the entire history of the medium.

Since these first three major publications hit the market, there have been numerous follow-ups and alternative histories of photography books published, as well as lists from other institutions, collections, and collectors.[9] What all of these compendiums demonstrate is that the interest in the book as a primary means of photographic expression continues to be on the rise.[10]

There are considerable resources available to any photographer keen on books (not the least of which are the aforementioned books and resources listed in the back). *Publish Your Photography Book* is, at its heart, a book about books, and a book that encourages you to think like a publisher. To those ends, in the pages ahead we'll outline everything you need to consider while working towards your goal of becoming a published photographer.[11]

Alex Klein, *Words Without Pictures*
(Aperture/LACMA, 2010)

802 Photo Books
(M+M Auer Collection, 2008)

Notes

1. Bill Jay, personal communication with the authors, 2003.

2. Barbara W. Tuchman, "The Book" (transcription of a lecture given at the Library of Congress, Washington, DC, 1979), 13.

3. *The Pencil of Nature*, published by Longman, Brown, Green & Longmans of London, was released in six separate installments between 1844 and 1846. It is considered the first commercial, photographically illustrated book.

4. For a brilliant description of the revolutionary impact of both increased human travel speeds and stop-action photography on people's sensory perceptions of the world, see Rebecca Solnit, *River of Shadows: Eadweard Muybridge and the Technological Wild West* (New York: Viking, 2003).

5. Shelley Rice, "When Objects Dream," in *The Book of 101 Books: Seminal Photographic Books of the Twentieth Century*, ed. Andrew Roth (New York: PPP Editions, 2001), 3.

6. The are multiple reasons as to why, at this moment in history, there is a sudden interest in photography books. If anything, it is due to a culmination of this multitude of explanations. The flourishing of Internet-based commerce coupled with a thrift-store-scouring mentality on the part of nascent collectors is no small driving force. It has only been since the late 1990s that serious e-commerce has been available. The stock of out-of-the-way used bookstores around the country suddenly became as accessible to an international audience as New York City's Strand bookstore's own wares. Editors and authors also took the end of the millennium as an opportunity to publish "Best Of" lists. This was not limited to photography books: there were books on the best albums, novels, book cover designs, concerts, etc., all hitting the shelves between 2000 and 2002.

7. Roth, introduction to *The Book of 101 Books*, 1.

8. Martin Parr and Gerry Badger, *The Photobook: A History*, vol. 1 (London: Phaidon, 2004).

9. In the few years since the Roth and Parr and Badger books were released, various subject-specific and collection-based volumes have been published, including *Books of Nudes* (New York: Harry N. Abrams, 2007), *The Open Book: A History of the Photographic Book from 1878 to the Present* (Goteberg: Hasselblad Center, 2005), and *802 Photo Books: A Selection from the M.+ M. Auer Collection* (Hermance, Switzerland: M. + M. Auer Collection, 2008).

10. Andy Adams of *Flak Photo*, an online photography magazine, and Miki Johnson of the liveBooks blog, Resolve, hosted in the fall of 2009 a "crowd-sourced" blog posting on "the future of photography books" that featured over forty individual posts by writers and photographers from across the publishing and photography spectrum.

11. Portions and/or excerpts of this chapter were previously published in Alex Klein, ed., *Words Without Pictures*, (Los Angeles: Los Angeles County Museum of Art, 2009); and Klein, *Words Without Pictures*, 2nd ed. (New York: Aperture, 2010), organized and published by the Wallis Annenberg Photography Department, Los Angeles County Museum of Art, and originally appeared on the website www.wordswithoutpictures.org.

INDUSTRY VOICES

————

Jeffrey Ladd 5b4 blogger and publisher, errata editions

What makes a photobook great is often a mystery, and the reasons, of course, will vary from person to person. For me, generally speaking, great books are those that ask questions and leave the viewer unmoored, seeking out anything meaningful in the relationship between the book and the viewer. By contrast, books that tackle and pin their subjects with either a forced concept or exhaustive explanation tend to be less interesting to me. I find that reading a book, especially a photography book, is a very intimate act, and those books that surprise and that inspire thought are most likely to avoid becoming dusty.

All books come with their own set of operating instructions. Those are formal elements, either in design or construction, that dictate how the book is read. For instance, in Western countries, books are read from left to right and the pictures oriented to the page so that the book is held in a single position from page to page. A great book can have these types of requirements but also work in a variety of ways, knowing that a viewer can approach the book with differing degrees of attention. It is common, for example, for people to pick up a book and flip from back to front instead of front to back. A great book dictates those reading instructions but also works when they are broken.

Another huge factor is longevity. What makes you pick up a book more than once? With many titles, the concept, or "meaning," is so obvious that it doesn't ever need to be picked up again. I have hundreds of books that, although I may like them for one reason or another, I never feel it necessary to look at again. It is a simple question of whether I am engaged enough to need a continued relationship with this object and this body of photographic work.

My interest in photobooks started in the late 1980s, at a time when you could actually keep up with all of the books published in any given year. Today there are so

Books on Books #5, #6, #7 and *#8*
(errata editions, 2010)

many small publishers and people self-publishing—the sheer numbers of different titles makes it hard to keep up with what is released season to season. Why this is, I think, is partly due to the rise in the popularity of photography as an artistic medium in the past ten years. Also a renewed attention to the older master photobooks has generated a wonderful resurgence of artists working in the book form with publishing as a goal. I think technology has had much to do with this. The fact that one can now produce, with little expense, a fully realized book dummy through ink-jet technologies is a huge benefit.

What I appreciate about some contemporary books is there seems to be an attempt to expand the book object out of the traditional form. Can a book be one photograph or one sentence (Paul Graham's *a shimmer of possibility* [steidlMACK, 2007])? Are all of the elements the book contains thought out or necessary (Michael Schmelling's *The Plan* [J&L Books, 2009])? When is design just for design's sake and when does it transcend into meaning and add to the photographs (Raimond Wouda's *Sandrien La Paz* [By the Way, 2003])? This has always been explored to an extent, but now many younger photographers and artists see the book as a statement more than just a bound portfolio of a group of pictures. Their idea of what a book is has changed. Again, perhaps this is partly due to technology, which aids in minimizing risks in time and expense.

2

The Nuts and Bolts of Publishing

Why Do You Want to Publish?

It almost goes without saying that every photographer wants a book of his or her work. It's a major milestone, an indicator of success and recognition, and a chance to place a selection of one's work in the hands of hundreds, if not thousands, of people. Plus it is just plain exciting to hold a book of your photographs!

There has never been a better time than now to publish a book of photographs. It is true that the illustrated book market continues to shift as a result of changes in the broader publishing arena. Larger publishing houses are grappling with major changes in technology—as evidenced by the popularity of such devices as Amazon's Kindle and Apple's iPad—as well as buying habits of the general public. However, smaller art book publishers, like Aperture, Steidl, Nazraeli Press, J&L Books, and others, are flourishing. And the advent of print-on-demand (POD) technology has placed a finished book of work well within the grasp of many photographers. Likewise, general interest in photography in the art market has been growing, and continues to grow steadily, and a more diverse range of artists and photographers, amateur and professional, are finding it possible to publish their work in book form.

You may be wondering how the publishing world operates or how you get a book of your work published. The publishing industry can be rather opaque to an outside observer. In the following pages, we will crack open the door and look at how publishing houses operate, how editors think, and how photography books come into being.

As with any meaningful undertaking, small or large, it's best to know what you want to accomplish *before* you get started. Many photographers will openly state, "I want a book of my photographs," without having fully grasped why they

want to publish or what type of book will best serve their career. Asking yourself questions about your objectives can really help to fully understand the task at hand and discover the proper means for its realization. The first question to ask is "Why do you want to publish?" The answer may seem so obvious that you have never stopped to thoroughly outline the goals you want to achieve.

There are essentially three elements to the declaration "I want a book of my photographs": the "I," the photographer asking the question; the "book," an object in its own right; and the "photographs," the basic content of the book. A close look at the statement reveals the basic drive behind publishing a book.

Let's first think about the photographer, the "I" in this equation. It's important to ask yourself some serious questions and really identify what you want to accomplish. You may be a serious enthusiast who wants to pull together your best work in book form for family and friends, or you may have an in-depth project of local significance that you'd like to memorialize. Perhaps you are a career professional photographer who is locally or regionally recognized and would like to expand to a more national audience. Do you have gallery representation already or are you seeking it? What type of photographic work do you produce, and are you trying to shift focus? For example, are you a commercial photographer intent on establishing a fine-art career? Do you work for a local newspaper and want to freelance for larger publications? Do you have three years or thirty years worth of work under your belt? Are you a recent graduate trying to figure out a way to promote your work and expand your artistic credentials?

As you assess your strengths and weaknesses, ask yourself what specific purpose you want your book to serve. Beginning to answer this question will lead you

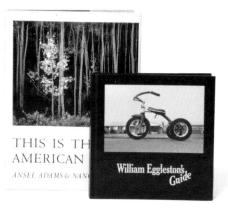

Ansel Adams and Nancy Newhall, *This is the American Earth*
(Sierra Club, 1992)

William Eggleston's Guide
(Museum of Modern Art, 2002)

to consider the type of audience you intend to reach through publishing, as well as which body of work may be most appropriate for publication. Perhaps gallery directors and collectors are your top priority. Perhaps you're looking to reach art directors at magazines, or maybe a regional artist-grant board, or the impulse buyer at Barnes & Noble. Who do you want to reach, and what type of book will best access that audience?

The second major element in the phrase "I want a book of my photographs" involves the physical book itself. What comes to mind when you hear the word *book*? Is it Henri Cartier-Bresson's *The Decisive Moment* (Editions Verve, 1952) or Ansel Adams and Nancy Newhall's *This is the American Earth* (Sierra Club, 1960)? Is it *William Eggleston's Guide* (Museum of Modern Art, 1976) or Lauren Greenfield's *Girl Culture* (Chronicle Books, 2002)? Answering all of these questions is part of an intense research phase on your part that will help you understand your motivations in wanting to make a book.

The third part of our statement involves the photography itself. A great book—whether a book of photographs or a literary work—begins as an idea, a thesis, and builds from there. It is the same with great photographs and photo projects. While photography-book publishers use diverse criteria to evaluate the potential of your book and how best to proceed toward publishing, it is crucial that you first set down for yourself the major reasons you have for publishing a book.

You Have a Story to Tell.

Many photographers approach the discipline from the documentary and journalistic tradition. Historical photographers like Dorothea Lange, Walker Evans, and

When I make books I try to keep them slim and tight—less really can be more. My books have all contained only thirty-five or fewer images total. I edit ruthlessly and work endlessley on the sequence. I am not afraid to put things aside or save them for later.

Todd Hido photographer and avid bookmaker

———

W. Eugene Smith paved the way as great storytellers, and we came to know their work through the printed page. There may be a story you've been working on for several years already that deserves to be published or one inside you that is ready to be told. A searing documentary photo-essay crafted to affect social change may be your intent, or you may want to tell a story about your local community. Regardless of the narrative or its length, the storytelling voice has a strong place in the history of photography.

Your Inner Artist Has Something to Say, and It Cannot Wait!
For many photographers, a book of photographs is a mini-exhibition sandwiched between covers. For others, the book itself is the medium. Regardless of the approach you take as an artist, the photography book can be a valuable part of your creative output.

You Want to Take Your Career to the Next Level.
A book often signals a leap forward in a photographer's career. It can serve as a portfolio of a single body of work, or it can function as a portable survey of one's career. It can be an introduction to one's style and range, which is useful to print- and web-based magazine editors or agents who are constantly on the lookout for new talent. A slim book of photographs can also serve as a calling card within the photographic community, distinguishing your work and highlighting your dedication to the field.

Evaluating and Refining Your Concept

WELL DONE. AFTER BATTING AROUND THOUGHTS WITH FRIENDS AND COLLEAGUES, you've hit upon a great idea. Perhaps you've been working on it for the last twenty years, or perhaps it came to you in a fitful dream last night. It doesn't matter. Before you go any further, let's take a good hard look at whether or not it's a great *book* idea.

The Big Idea

The single most troublesome area for photographers is defining the concept of the book. A great book, as with a great photography project, is well-conceived and has a clearly defined subject. Donna Wingate, a bibliophile who currently works with book packager Marquand Books of Seattle and formerly headed D.A.P.'s (Distributed Art Publishers) publishing program, perfectly sums up the situation:

> *Emerging artists are faced with greater challenges. They have to compete for bookstore shelf space with recognized names (and, indeed, some living legends) who are producing vital bodies of work that are published with important museum exhibitions and the support system of their galleries and other cultural institutions. What really stands out when it comes to emerging talent is a project that can answer the simple question, "What is this book about?"*

This, then, is the fundamental question to ask oneself as a photographer. What is your project about? Taking into account things like subject matter, timeliness, and the current status of one's career will ultimately influence what sort of book you decide to pursue for publication.

The "big idea" of a book can take any infinite number of forms, and can be broad or narrow. One recent example is Andrew Zuckerman's newest book, *Bird*

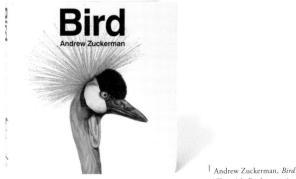

Andrew Zuckerman, *Bird*
(Chronicle Books, 2009)

(Chronicle Books, 2009), which takes a very straightforward and beloved subject matter—birds from around the world—and creates a catalog of species with stunning photographs that appeal to a very broad audience. Zuckerman is a talented studio photographer, and, along with his previous title, *Creature* (Chronicle Books, 2007), his books have brought him a certain measure of fame, but the birds themselves are the main draw and selling point for a subject-driven book like this.

A more narrowly defined (and deceptively titled book) is Martin Parr's *Mexico* (Chris Boot, 2006). While the title of the book is the name of the country, the book contains a very particular view of tourism and economics as seen in border towns of the U.S./Mexico border. The photographs are all shot in Parr's signature hyper-saturated style, and while the title indicates a broad subject, it is in fact Parr's photographic vision and take on the crass side of globalization that is more properly the subject of the book.

Even with Parr's international reputation within the fine-art-photography community, sales of *Mexico* would have been well under 5,000 copies, while the broad public appeal of birds will guarantee that Zuckerman's *Bird* will sell ten times as many copies.

Who Is Your Audience?

Defining the audience for your book is nearly as important as producing the work itself. Many aspiring photographers make the mistake of assuming their book or project has a huge potential audience: "everyone who loves photography," or "all dog owners," or "anyone who travels." For the most part, broad generalizations like this are not true. Most readers, like most art and photography connoisseurs, have

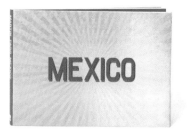

Martin Parr, *Mexico*
(Aperture, 2006)

particular tastes, which means that you must define a core audience to whom you can tailor and target your book.

Sometimes, the way other industries market to their audiences can provide clues for how to identify and market to your own community. If your project is subject-driven, start building a library of other books about this same subject. Researching magazine sales and online groups devoted to the subject matter is another great way to determine the potential size of an audience.

While there is no hard-and-fast rule on how large a potential audience for a particular title needs to be, there is some common thinking that we have discovered in talking with publishers from around the world. In the world of art- and photography-book publishing, most publishers see three thousand copies as the upper limit of a book's potential market, and the range of quantities varies widely and depends on various factors, including cross-marketing potential, name recognition of the photographer, and supporting activities, such as exhibitions or corporate sponsorship. In truth, small fine-art publishers will print as few as five hundred to a thousand copies of a book, while the larger houses search for titles that have a potential audience of eight to ten thousand copies or more. The particular artistic vision of one artist—Lee Friedlander, for example—may have a very limited audience, whereas a universal theme rendered through easily accessible photographs—like Andrew Zuckerman's *Bird*—may sell upwards of fifty thousand books.

S, M, L, XL Book Projects

Some photography projects make great magazine articles but don't have enough depth to sustain an entire book, whereas some seemingly narrow magazine

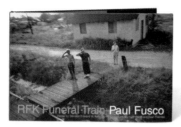

Paul Fusco, *RFK Funeral Train*
(Umbrage Editions/Magnum Photos, 2000)

articles end up filling the pages of a book perfectly; other photography projects are overly ambitious, bordering on encyclopedic in length. Bernd and Hilla Becher have been photographing a very narrow but deep subject—vernacular domestic and industrial architecture such as blast furnaces and suburban German homes—for over fifty years. They have published many books from this overarching project, and each book focuses on a small slice of the larger project.

Considering how to organize and categorize your project at the start, as well as visualizing the end at the early stages, is paramount to the success of a book. Writing a summary or a brief outline of an intended photography project can often help you to realize the depth and breadth of the project, and to help approach it systematically.

Sometimes a project is strictly limited simply by circumstance. Paul Fusco's *RFK Funeral Train* (Umbrage Editions/Magnum Photos, 2000) is a perfect example of such a project. The photographer rode on the train carrying Robert F. Kennedy's body from New York City to Arlington National Cemetery in Washington, D.C. in 1968, making photographs of the mourners who gathered beside the railroad tracks along the length of the journey.

At the other end of the spectrum is the career-long photographic project of husband and wife Bernd and Hilla Becher. Taking increasingly obsolete industrial architecture as their subject, they have applied a rigorous intellectual and formalist aesthetic to their photographic practice, producing a body of work that continued until Bernd's death in 2007. From this vast body of work of an equally extensive subject have come numerous, diligently edited books that focus on specific aspects of their oeuvre.

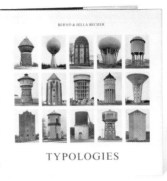

Bernd and Hilla Becher, *Typologies*
(Schirmer/Mosel, 1990)

It is helpful to have a picture of where your particular project fits into an overarching vision of your own photographic practice and also within the history of photography and image-making. This will greatly inform the way you approach the concept of your book and any other books you make in the future.

Having stated that, there are plenty of projects that won't be easily classified, nor should they be, having come from the creative mind of an artist. The point is to be consciously aware of how your project fits into the world of publishing and to pursue the path that makes the most sense for you.

Learning From Other Books

Books are physical, three-dimensional objects made, in most cases, of paper and ink. They are also multifaceted objects requiring a range of skill sets to produce that you alone probably don't possess. Because a photography book is such a different type of book than a text-based work, getting your head around how the multitude of parts function together is extremely important, and we suggest that this is where your research phase begins in earnest.

Pull out a pen and paper and jot down the titles of a few of your favorite photography books. For each title, list specific elements of the book such as the exact page count and number of illustrations; describe the binding, cover material, and end sheets inside the front and back covers. What type of paper is used? What fonts? What are the final dimensions of the book (the "trim size" in publishing terminology)? Are the illustrations four-color or duotone or some other type of printing process? What about packaging materials? Does the book have a dust jacket or slipcase? All of these are details that relate to books as objects, and

becoming familiar with the vocabulary that designers and publishers use will ultimately serve you well.

Throughout this research phase, you will undoubtedly come across books that excite you as well as ones that leave you cold. Be aware of all of your gut-level responses, and consider carefully the role the photographs themselves play within the book form. If you really love a particular book, ask yourself why. Is it the strength of the photographs themselves or the idea behind the images that moves you? Do the proportions of the book feel good in your hands or is it the feel of the cover material or perhaps the texture of the paper?

In other words, pay attention to all of the aspects of a book. Some of the major elements to consider are the following:

Subject Matter: What is this book about? Can you summarize the subject in one clear sentence? The subject matter needn't necessarily be of deep importance or pressing social relevance—anything from apples, airplanes, bikinis, and bulldogs to the conflict in Kenya or Karachi is a legitimate subject for a book. What a publisher is looking for is a powerful vision, regardless of whether it is personal or universal.

Cover Design: Really consider the image that was used for the cover as well as the cropping (or not) of the image, the placement of the title, and the overall impact of the cover design.

Strength of the Photography: What makes the collection of photographs stand out? Does it communicate the photographer's intention? Is there a singular artistic vision? Does the style of photography and camera technique suit the subject matter? Does the work feel amateurish or aesthetically sophisticated?

The most important factor to me is the quality of the visual imagery in terms of process, selection, and sequencing. The test of quality should be based upon on the number of levels in which we are engaged visually, emotionally, and intellectually.

Dale W. Stulz appraiser and consultant in fine-art photographs

———

Page Layouts: The placement of the images on each page as well as the consideration of the entire double-page spread is worth noticing. Page layout is extremely diverse—images can run across the gutter (the seam joining the two facing pages of the book), can bleed off the page, and may vary greatly from page to page and from spread to spread. Does the placement of images seem based on conscious choices or haphazardly situated? Is there a visible logic to the design of the spreads and the presentation of images? How do the photographs relate to the captions and any other text on the page? Does the layout feel dated or overly designed?

Text: Fonts and typefaces are an art form with a rich history, and typeface design is a craft to which people devote their entire lives. As with any and all aspects of the design of a book, it's best to leave the design to the designers. A great photography book will be one that has a sophisticated and considered use of text and fonts. You can really become attuned to fonts by studying some of the classics of any genre.

Editing and Sequencing: Editing a body of photographs is a unique skill. The editing process—deciding which images to include and which to leave out—requires clarity of vision and a powerful artistic voice as its goals. Sequencing those images is the next logical step of the process. When researching books that you really respond to, be especially attentive to the selection of images and sequence of the overall book. If the body of work has a narrative quality, take into account the success of the story.

Impact of the Overall Book: How much does this book stick with you after viewing it? What is its lasting power? Do you want to pick it up again? Some of the most powerful books come in small packages—be wary of thinking that bigger is better when it comes to a photography book.

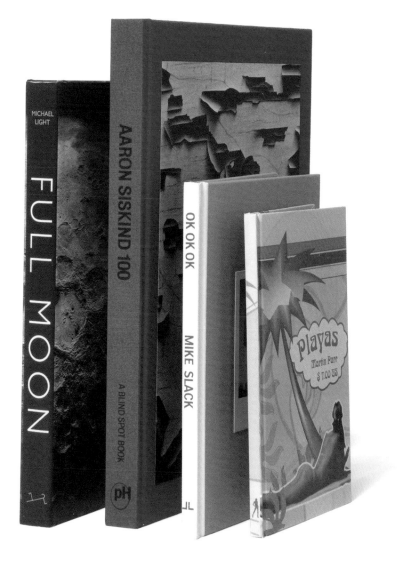

Henri Cartier-Bresson, *Full Moon* (Knopf, 1999)
Aaron Siskind, *100* (Blind Spot/powerHouse Books, 2003)
Mike Slack, *Ok Ok Ok* (J&L Books, 2002)
Martin Parr, *Playas* (RM Editions, 2009)

Equally important to this process is to identify books that you really dislike. Again, ask yourself why. Look intently at all of the elements that we've just outlined and note what works and doesn't work in your opinion. Thinking about all of these questions must tie into your overall goals and the audience you want to reach. Having carefully articulated your likes and dislikes, and the underlying intent of your project, will vastly help you in determining the publishing route you will take, what you want that book to look and feel like (in a broad sense), and which publishers might be appropriate for your project. (See a listing of photography book publishers in Section 6, Appendix III, page 204.)

Refining the Concept

Living the life of a photographer and, by extension, working on a book-length photography project, takes a great deal of commitment. There are no professors or parents standing over you with assignments and deadlines, and encouragement is often hard to come by. The number of distractions is too many to count. Organization, organization, organization is the only way to stay on track—that, and a lot of self-determination.

Creating a book is a process that involves, at the least, several people. In order to refine the central concept of your book, turning to friends and colleagues for input on your book concept or the strength of the editing and sequencing is a good idea, as is coming up with a plan that will help you visualize the end of the project even as you attempt to initiate it. Create lists of tasks you need to accomplish— whether they are soft tasks, like researching publishers, or hard tasks, such as hiring a designer—in order to keep moving forward.

Behind the Editorial Door: Understanding How Publishers Work

A MAJOR GOAL OF THIS BOOK IS TO REVEAL TO YOU HOW PUBLISHERS THINK AND to help you, the photographer, to think like a publisher. What is challenging about that task, of course, is that photography and art book publishers are wildly diverse. There are, however, several similarities in the way all publishers approach taking on a new book project. In order to submit your proposal to the right publisher for your project, it helps to understand the inner workings of a publishing house and how decisions about which books to publish are actually made. Who are the main figures you'll deal with? What are the key factors involved for a publisher in deciding to take on a book?

The Core Team of Players

Whether the publishing company is large or small, the core team of players will represent a combination of art and commerce; this pairing ensures that a publishing project is viable for the company, both according to their overall mission and aesthetic sensibilities, as well as in financial terms. As with any team, each individual that participates in the publishing process brings his or her own skills and passions. You will gradually learn to appreciate the specific strengths of your collaborators and what skills they bring to the project.

In an ideal world, you will have the pleasure of working with very creative editors and designers who have a strong awareness of the market, along with engaged marketing personnel who have an entrepreneurial and web-savvy approach. And, of course, remember that there will always be someone on the publisher's team keeping an eye on the bottom line.

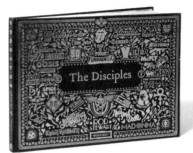

James Mollison, *The Disciples*
(Chris Boot Ltd., 2008)

The Publisher

In the language of the publishing world, the Publisher is the person, whether as owner or employee, who oversees the entirety of the operations at the publishing house. Which titles are acquired, how many copies are produced, the final say on the design of each title, and the branding of the entire company—all of these aspects are under the direct guidance and control of the Publisher. In the world of fine-art-photography-book publishing, the Publisher and the acquisitions editor are often one and the same person. (We use the word *publisher* to describe the overall company and *Publisher* to describe the person.)

The Acquisitions Editor

At a publishing house there is often one or more individuals who are tasked with finding new projects. The acquisitions editor does just that: they acquire, through various channels, book projects for the publishing house. It is the acquisitions editor who will present your work at an editorial meeting and who will be your advocate. In larger houses, this function is quite formalized, whereas in smaller publishing companies, virtually anyone on staff can present a project at an editorial meeting.

Whether you have targeted and approached a publisher that you believe is likely to be a match for your project, or an editor has expressed interest in your work—either in direct communication or at a portfolio-review event—be sure to provide them with anything they need to best serve you in that role. A clearly written paragraph about your project, a full set of image files at whatever scale they request, or a professional resume will help communicate your ideas to the members of the editorial board.

When considering a project, it always makes sense to look at earning possibilities from significant serialization opportunities in magazines, potential for sales of limited editions to collectors, and exhibition opportunities with public institutions.

Chris Boot publisher, Chris Boot Ltd.

———

The Content Editor

Much of the impact that your book will make on your audience and, ultimately, on the marketplace will be due to the content editor (also called the developmental editor), who may or may not be the same person who initially acquired the project. Whether you work with a freelance editor or are assigned an in-house editor, this is the person who will shape your visual and textual materials, and your vision, into a project fit for publication.

Actively shaping your materials into a presentable book is often the most creative stage for an editor. At some publishing houses, there is also a third type of editor, the production editor, who is responsible for realizing all of the content ideas that have been discussed up to that point. Don't underestimate either the editor's skills or their own emotional involvement, which is both natural and necessary. You want an editor who is engaged by your book and who is fully involved in and supportive of the project, since the goals of both you and the content editor are united—the success or failure of the book determines, to greater or lesser degrees, your careers.

The Designer

Many publishing companies use both in-house and freelance designers, depending on the project. Designers have the all-important task of translating your photographs and the text from you and your contributors into book form in such a way that the result is more than the sum of its parts. They help to promote your work while also working to advance the overall brand and creative style of the publishing house. Many publishers will use freelance designers, at times, for individual

Darin Mickey, *Stuff I Gotta Remember Not to Forget*
(J&L Books, 2007)

projects and in-house designers for books that are part of either an on-going series or sit at the core of the publishing program, where a visual continuity is vital to the identity of the press.

Other Players: Agents

As in many fields, there are individuals who can be retained to pitch you or your project to those likely to be responsive; this is true in book publishing as well. Many successful book agents began their careers as in-house editors for larger publishing houses and bring hard-earned experience, insight, and practical advice to a book project. Photography books are generally considered a niche market, and consequently, there are fewer book agents in this field than in other market segments of the publishing industry, such as fiction and creative nonfiction.

The role of the book agent—whether working individually or as part of a literary agency—is to secure publication for your project. The agent targets and approaches specific publishers on your behalf and helps negotiate all of the financial arrangements. This relationship generally continues when discussing a second printing of the title or any subsequent versions or editions of the book. Book agents typically do not become involved with any of the production issues, and they are often remunerated by a percentage of the advance that they are able to secure for you from the publisher.

If your proposed book has a specialized subject, and particularly if that theme has universal appeal, you would be wise to try to identify an agent. A general rule is that the broader the audience, the more important it is to work with an agent. An agent will have contacts in the publishing world that may be interested in your

We publish work that we find original and inspiring. We are especially drawn to work that has a nice mix of sentiment and abstraction, also humor and beauty. Ideally we'd like to mix up audiences with the diversity of what we're publishing.

Jason Fulford cofounder, J&L Books

———

proposal, as well as other recommendations particular to the subject matter, such as suggestions for authors or celebrity endorsements.

Other Players: Packagers

Many publishers today do not have the means, or the staff time, to develop a complete roster of books in-house during each publishing cycle, or "season," nor do they want to bring books toward publication that are extremely labor-intensive with complex production requirements. They may, however, be interested in acquiring a book that arrives complete, i.e., designed, printed, bound, and ready to have their logo stamped on the spine. This is a packaged book, and it comes to the publisher as a completely produced, ready-to-ship book. Packagers (sometimes called producers) often approach publishers and offer projects that they have come across or developed in collaboration with a photographer or author.

Book packagers often differ in terms of what stage of the publication process they complete: some will deliver shrink-wrapped titles to the publisher, having been intimately involved with every step of production. Others will handle production of the book up to a certain point, handing it off to the publisher to complete. Most packagers see the project through each and every step of the design, print, and publication process. At what point the acquiring publisher will take over the process depends on how the contract is negotiated. Book packagers are generally credited on the copyright page of a book, and their financial remuneration is often based on how many copies they are able to place with a publisher.

INDUSTRY VOICES

Robert Morton editor, agent, and consultant

The most significant change to the publishing industry in the past decade is the loss of thousands of independent booksellers, the concentration of power in the hands of only a few retailers (the chain stores), and the conglomeration of publishing companies in the hands of only a few mega-corporations, which are run by corporate executives, not true publishing professionals. On the other hand, the rise of online and other short-run, POD services has enabled more photographic books to come into existence than ever before. The problem is that these books cannot find their way into a marketplace that has too few venues for their exposure and sale. Will online bookselling (from Amazon on down) provide those venues? That remains to be seen.

The decrease in personal sales outlets run by people who knew their audiences and often had the courage to stock risky or otherwise narrow interest books has led the full-line illustrated book publishers to cut back on the number and type of photographic books they publish. With corporate executives running companies, only those books that are seen as having potential for high sales volume will be taken on. This is not the case with most photographic books, particularly monographs or books of personal expression, which are the riskiest and most hard-to-define books of all. That has always been the case. In the past, however, courageous publishers could and did take chances based on their taste and instincts. With corporate executives trying to rationalize the publishing business, decision-making has been handed over to sales and marketing personnel, as if they know for certain the books that would succeed, which they do not. No one can know for certain, but good, experienced editors and publishers once had the opportunity to make commitments to artists and subjects they believed in—that is how publishing truly should work. Everyone is wrong some of the time anyway.

The audience for serious, artistic books of this kind has been and always will be limited. Surprisingly, although more and more people are making photographs and more and more museums and galleries are showing photographs, the audience of people actually buying photographic books has not grown. Why doesn't this audience support their interest by buying more books? That's a mystery of the ages, similar to the one affecting the poetry audience: more people write poetry than ever, but poetry book sales are stagnant. That's just the way it is.

The most hopeful signs are in the possibilities offered by online or other short-run, on-demand printing facilities. If a publisher or an artist can create a book without dedicating the large investment required for a quality offset-printing job, there is a chance that the modest, less-than-perfectly-produced book can be used to find an audience, and perhaps later reprinted through traditional publishing methods with higher-quality production. There is also the possibility that short-run, on-demand printing will itself improve in quality and lower in cost so that books printed in this way can find a way into the marketplace. (With the current high costs—about $10 or more per copy—there is almost no way for it to come onto the market at an affordable retail price, which have to minimally be at least five or six times the cost per unit).

The future is both limited and potentially expansive. Change is happening very quickly. We will wait and see, and keep pushing the limits of what we think is the only answer.

Michelle Dunn Marsh freelance designer and editor; copublisher, *Aperture* magazine

A trade magazine is a periodical geared to a specific industry. Oddly enough, a trade book is the opposite, aimed toward a general public and meant to appeal to the widest possible audience. If the project was initially conceived as an art project, or an artist's book, a publisher like Aperture or Chronicle Books will work with them to adapt it into a more accessible trade edition. The difference between the artist's book and a trade edition is essentially quantity and availability. An artist's book is often made in extremely limited numbers, from one to forty, for example, and is available directly through the artist or from their galleries. A trade book is published in quantities of a thousand or more and is available through normal bookselling channels. *Scotlandfuturebog* by Nicholas Kahn and Richard Selesnick (Aperture, 2002), *A Couple of Ways of Doing Something* by Chuck Close and Bob Holman (Aperture, 2006), *Pictorial Webster's: A Visual Dictionary of Curiosities* by Johnny Carrera (Chronicle Books, 2009), and *Apples I Have Eaten* by Jonathan Gerken (Chronicle Books, 2010) are all examples of projects that originated as artist's books but were made available to the public through a trade edition in which the original content was extracted and adapted to an affordable package.

Every publisher has a slightly different agenda for their book program and their intention in making books. At a trade house, the purpose in choosing projects is to produce books that make money and that are of interest. A nonprofit publisher—be it of poetry, fiction, or photography—has a mandate toward a particular area of focus and may choose projects that do not necessarily have great financial potential but which are deemed important and should be seen by a wider audience. Nonprofit publishers often seek financial support through grants or individual donations in order to publish in their area of interest.

Photography-book Acquisitions

What is important to remember when thinking about photography-book publishing is that the field of publishers is as varied as the field of photographers. Publishers see themselves as specializing in certain subjects: fiction, literary nonfiction, travel writing, children's books, illustrated books, books on the arts, design, architecture, and yes, photography. Most publishing houses follow a certain vision—a mission statement—that comes down from the top. Each Publisher or acquiring editor, no matter the size of the house, curates a list of books that fulfills the objectives of the press. Acquiring books and building this list, as well as working with the artists and authors, is one of the most creative aspects of an editor's or a Publisher's professional life.

But depending on the size of the house and the range of books an editor is responsible for, there are various factors that play into how projects are first considered and then acquired. The following are some general guidelines for how acquisitions happen at some of the medium-to-larger publishing houses (smaller presses can operate much more idiosyncratically). Regardless of whom you end up working with, being informed of this process will make you more confident.

The Editorial Meeting

Books are often presented at weekly or, more commonly, monthly editorial meetings. The meetings are forums for an editor to present promising leads and projects to colleagues within the company and to begin to build excitement about a book's potential. Representatives from other departments often attend these meetings to offer their thoughts about the potential viability of the project, either

INDUSTRY VOICES

Geoff Blackwell founder, PQ Blackwell

When we commission photographic book projects, we tend to agree on a general framework and then step out of the photographer's way so that he or she has creative space to interpret the theme without limitation or outside interference. The process we follow started with publishing the work of photographer Anne Geddes: we look for a subject matter that is relatively universal, with very broad appeal, and then search for someone to interpret that theme or subject matter in a fresh, commercially appealing way. We invest financially in that concept by commissioning the photographs, and then we sell those photographs as part of a package to a publisher.

Our primary editorial focus on new projects tends to be traditional large-format books. But we also seek photographs and themes that can be used in ancillary publications and for licensed products. We have learned not to be too prescriptive at the beginning of projects, as the best results happen when the photographer has creative freedom. This requires trust on both sides.

To find new work and projects, our approach is basically to look really closely at who is winning awards, what's going on around the world, and browse websites—we go to endless websites looking at work. To showcase your work brilliantly on a website is utterly crucial from our standpoint and is much more likely to lead to a publishing project than submitting a fully formed concept.

Phillip Toledano, *Days With My Father*
(PQ Blackwell in association with Chronicle Books, 2010)

from a financial, marketing, or editorial viewpoint. If the editorial board decides to move forward with a project after the initial pitch, the next step is usually for the acquiring editor to gather answers to questions that arose to present at the next editorial meeting, including the potential size of an audience, the length of the text and number of illustrations, and the financial viability of the book. Including this type of information in the initial submission is greatly encouraged because it often facilitates the decision-making process and minimizes the turnaround time for a response to the photographer.

While it is undoubtedly very exciting to have an editor come back and say the book has passed the first round, it does not guarantee that you will be offered a contract. Be sure to provide whatever the acquiring editor may need to help convince the Publisher that it is a book they should get behind as a company.

The Acquisition Process

After the initial editorial meeting, the acquisitions process will inevitably move through a series of steps that will differ from publisher to publisher. These steps may involve getting the opinions of other departments, such as marketing and sales; thinking about subsidiary rights (if the publishing company is large enough to handle it); inquiring about exhibitions that can be scheduled in association with the launch of the book; analyzing budget projections; initiating contract negotiations; and determining whether there is potential for ancillary products related to the title.

Making the decision to offer a photographer a contract is ultimately based on two things: first, if the book fits into the overall publishing program from a creative and editorial standpoint; second, if a book is financially viable. Oftentimes this is

A photographer should do research and become familiar with the publisher's previous books when he or she makes a first approach. A shared sensibility about what makes a "good book" is important for both.

Alexa Becker acquisitions editor, Kehrer Verlag

———

determined through a profit-and-loss analysis of the book (known as a P&L). To calculate a P&L, a list price is determined and estimates about the number of copies likely to sell are calculated. This is then balanced against the various costs involved, including author royalties, printing, manufacturing, distribution, marketing costs, and general overhead. Once the income and costs are estimated, the publisher can determine whether the book will be profitable for the company. Generally, publishers will not move forward with a book unless the P&L yields positive numbers.

Funding Issues

Illustrated books are, by far, the most expensive type of trade books to produce. The high quality of the paper used, the trim size and reproduction methods, the various materials involved, and where the book is printed all add up to an extremely expensive proposition. For larger houses, the answer to these costs is to acquire projects that will sell enough quantity to offset their investment. Books that tie into movies or are endorsed by celebrities, and titles that relate to current events or television shows have obvious value to larger publishers.

Being able to identify possible audiences outside of the gallery-going and fine-art-photography community is paramount in pitching a book to a mainstream publisher. Photography projects that are about popular or widespread subject matter have potential audiences that can reach well into the thousands and are most appropriately published through a larger publishing house.

For most photography projects, the audience will be 3000 people or less, and in the baldest terms, selling a complete run of 3000 books at a reasonable trade price (even for an art book) still won't cover the costs incurred to produce the book.

Jessica Backhaus, *Jesus and the Cherries*
(Kehrer Verlag, 2005)

So, what can you do? Many publishers actively use a teamwork approach to generate funds above and beyond the projected retail sales of the trade edition of books. Partnering with institutions such as museums and foundations and working closely with galleries and dealers are two tried-and-true methods. Implicit in the mission of public art museums, and many private foundations, is the goal of supporting and promoting the arts. Curators, museum directors, and gallery owners know that a book can extend the life of an exhibition, and funds for producing a catalog are often included in the overall budget of a planned exhibition. Because a museum may not have a publishing department, and most galleries definitely don't, they will often partner with a publisher to produce a book. This relationship may range from a credit line in the book or on the cover and spine to a copublication agreement between the press and the institution, but ultimately comes down to a sharing of financial responsibility for the publication.

Another way of supplementing the income from a trade book is to produce a high-end, limited-edition version of a book that includes an original print. The price of the limited edition will be set based on the artist's reputation, the cost of their photographs in a gallery setting, and the number of copies of the limited-edition book produced. There are many publishers that use this model and actively work to presell copies of a limited edition in order to cover the "hard" (out-of-pocket) expenses of a book. Working closely with collectors, gallery owners, and your own mailing list and social networks is paramount to the success of this approach.

The point to remember is that publishing a book on an artist is something that benefits all of the people involved. Small art publishers are in the business because they love the arts and photography as much as they love books, and they

Everything is a collaboration, with our staff choreographing interactions between our artists, writers, editors, printers, binders, papermakers, and, of course, our collectors.
Lance Speer contributing editor and director of marketing, 21st Editions

—————

want to promote the field by publishing artists and subject matter that they view as important. Galleries and dealers likewise want to see the careers of artists they represent advance, and a book often provides needed stimulus and cause for media attention. And, of course, as the photographer, you are keen to see your project published. When all three of these major players in the financial picture come to agreement, it makes a project that much more viable.

If this type of collaboration is not yet in place for you, some publishers will agree to produce and distribute your title, but with the requirement that you contribute outright to the cost of the book. A subvention, or subsidy, that covers some or all of the costs of the book is required in this scenario. For most artists and photographers, a published book acts as a stimulus for sales of their work, which will more than cover the cost of the book, making the effort and money invested worthwhile.

In this type of arrangement, you benefit by having an experienced company produce your title, and the publisher minimizes the risks in taking on a lesser-known photographer. You pay a set fee to the publisher in exchange for a publishing arrangement. Be mindful of knowing exactly what you will receive in exchange for your financial contribution (i.e., a stronger voice in design and production decisions, as well as the number of copies you receive once the book is printed) and whether or not the publisher will commit resources toward marketing your title. If the publisher will not be providing PR, make sure to budget accordingly in the event that you wish to hire an independent publicist to help promote the book.

Submissions and the Path toward Publication

A GREAT PLACE TO IDENTIFY PHOTOGRAPHY-BOOK PUBLISHERS IS YOUR OWN bookshelf! What are your favorite books? Which titles do you cherish and return to again and again? When guests whom you want to impress are headed over for drinks, which books do you put out on the coffee table? Besides your own book-shelves, head to a bookstore for further research. A good bookstore, be it a local independent, a national chain, or a museum bookstore, will offer a diverse selection of titles to review. As we all know, independent bookstores have not fared well in recent years, but every major city still has one or two art, design, architecture, and photography bookstores (see a list of independent bookstores on pages 208–10).

The Internet is another great place to start your research. There are several web-based directories and blogs featuring lists of photography book publishers (see a representative list of publishers on pages 204–6). There are also several independent bookstores that specialize in photography books and which have great websites full of information (such as photo-eye Books in Santa Fe, Dashwood Books in New York City, and Schaden.com in Germany).

One of the more unique and beneficial aspects of the photography community is the proliferation of portfolio-review events. Occurring either annually or biannually, portfolio-review events put photographers directly in touch with industry figures who can both benefit from and assist photographers in their careers. Gallerists, publishers, dealers, picture editors, agents, and other picture professionals are invited to attend review events, and typically meet with participating photographers in twenty-minute sessions over the course of one to several days.

Portfolio-review events offer terrific opportunities for you to meet face-to-face with these professionals. They afford you the time and place to create a network of

Barbara Karant, *Greyhounds*
(Packaged by Verve Editions. Stewart, Tabori & Chang, 2008)

picture professionals that are interested in your work and with whom you can begin a relationship that could result in a contract and a published book. Review Santa Fe (www.visitcenter.org), in New Mexico, has traditionally had a strong showing of American publishers, while The Meeting Place at the FotoFest Biennial (www.fotofest.org), in Houston, offers a broad range of international publishers. A favorite event in England is the Rhubarb International Festival of the Image (www.rhubarb-rhubarb.net), which also offers a slate of publishers within its reviewer roster—it is a must if your work has an audience in Europe.

You will want to do your homework before attending any portfolio-review event by visiting the websites of publishing-industry individuals who have been invited to be portfolio reviewers, and by looking at their books and any ancillary products firsthand. Make a short list of whom you would like to speak with. Don't forget that your photography career should be multifaceted; try to speak with a range of professionals in addition to publishers. Meet with gallery and museum curators and magazine editors with the aim of securing events and press that can be tied to a forthcoming book.

Approaching a Publisher

In the world of photography book publishing, the packet of materials that is sent to a publisher is often *not* their first encounter with you and your work. An editor might have seen your work either at a gallery or a portfolio-review event or seen a photo-essay in a magazine. But submitting a proposal is still considered a formal procedure that officially represents your project.

The most effective way to present a project is to place a fully realized mock-up of the book into the hands of the prospective publisher. This should replicate the intention of what the finished book will be.

Gary Chassman president, Verve Editions

———

Submissions can take many forms and most publishers want a coherent proposal that is easily reviewed and presents an awareness of the audience and marketplace. There is no one formula for submitting your work to a publisher for consideration, and official submissions guidelines vary from publisher to publisher. Every company will have its own review procedures. You will want to follow their stated guidelines to the letter. They may not want to be responsible for (nor have the storage space for) a box of eighty original, museum-quality exhibition prints, for example. Some will review proposals; others, not unlike galleries, will only see work that has been referred to them by trusted sources. CD-ROMs, book maquettes, and boxes of prints are often the format requested. A website is a must in today's photography world, but it is generally not an acceptable substitute for a formal project proposal.

There are basic topics that you must be prepared to speak to when you are presenting a publication proposal, whether via their submission procedure, in person at a portfolio-review event, or at the publisher's offices. You will want to have fully researched who you believe the audience is for your book, as well as any special groups and membership organizations that would be interested in buying your book, and know the number of individuals this translates to.

Be entrepreneurial in your research! If your book is subject driven, look at local, regional, and national organizations related to your topic. You will want to know what other competing titles are in print, when they were published, and how well received they were. Be sure to research the potential for exhibitions and other public display of the work that can be arranged to correspond with the release of your book.

INDUSTRY VOICES

Joan Brookbank independent advisor and longtime publishing director

The key to attracting a publisher's attention is strong work combined with old-fashioned courtesy during the submission process. When I review good work presented in a thoughtful, organized manner, and the sender is courteous to boot, I pay more attention. And why not? Smooth relationships among all parties involved in producing a book and launching it into the world can often make for a better, more profitable book. It definitely makes for a more meaningful and enjoyable experience.

I like to receive a query with no materials and especially with no large files attached, inquiring as to whether I am willing to receive a submission. Once agreed, I like to receive a nice, neat, concise cover letter; a link to a selection of images that do not require extra software or special skills to access; and a professionally organized proposal clearly and realistically indicating why the project is book-worthy and marketable. A realistic approach suggests to an editor that the sender will be more reasonable as a colleague during the making of the book. The proposal should feature the usual elements, including a brief description of the book project, a list of key selling points, an author biography, and any information regarding current, prior, or future gallery or museum presence.

One can argue that a better, more commercial book results from team efforts. But we all know that sometimes books are compromised as a result of the realities of the business of publishing. That said, books that are both meaningful and successful continue to be published through combined efforts and expertise.

What has not changed fundamentally is an idea I once heard Ingrid Sischy (former *New Yorker* photography critic and former editor of *Interview)* express at a dinner when an author was lamenting the many discouraging problems that arose during the publishing process. Sischy listened quietly, offered her sympathy, and then gently but firmly reminded the author, "Every book is a miracle." Indeed, every book is a precious object, and making a book can be an intoxicating, if sometimes imperfect, experience!

A typical stack of unsolicited submissions

At the editorial level, taking on a book happens in one of two ways: we actively pursue photographers whose work we are interested in, and we're constantly reviewing the work of photographers who contact us directly.

Deborah Aaronson editorial director, Abrams

————

If your photographs have been in print previously—in magazine, exhibition catalog, or book format—be sure to include a list or reproduction of publications with the proposal submission, no matter how insignificant it may seem. Exposure in any of these formats helps build your name and image recognition in the public mind, and a publisher will want to know about these connections. These published pieces, along with exhibition announcements, an artist's statement, and critical reviews of your work should also be included with your submission materials. Be sure to clearly indicate which, if any, of the materials you provided must be returned (provide a pre-paid Fed Ex or UPS label). The materials you allow them to keep on file should be easy to store and serve as visual reminders of your project, with your contact information readily accessible within.

It is likely that whomever you submit your work to will not be the final decision maker, so submitting something that can be easily shared with colleagues is imperative. While some publishers welcome a book dummy or mock-up with the proposal, complete with layout and design considerations in place, others may prefer a simpler, no-frills approach. Be sure to ask ahead of time if the guidelines are not clear.

Once you submit your publication proposal, do not call, email, or otherwise pursue a reaction to the submission. Have patience with the process. You don't want to be remembered for your lack of courtesy—you want to be remembered for the strength of the work. The duration of the editorial review process can vary widely from publisher to publisher and even from project to project. A several-month waiting period is not uncommon.

Reading a Publishing Contract

CONGRATULATIONS! YOU'VE GOT AN OFFER FROM A PUBLISHER!
The months of research and the hard work of putting together a promotional piece and a book proposal has paid off—your goal of publishing a photography book is within sight. Once the initial rush of adrenaline fades, you'll need to take a serious look at the contract that is being offered to you.

Before you sit down with the contract, take a minute to think about the business of publishing. There are various industry standards and guidelines that play a role in the contract negotiation. There is also the economic reality of publishing art books—it is a difficult business where the revenue is divided between many players.

Throughout this process, remember what your goal is: to present your work in book format for the enjoyment of an ever-growing audience. Keep this in mind and tailor all decisions to that end. Contract negotiations are just that, negotiations. While there is likely to be room for discussion on most parts of a contract, there will be items that are simply nonnegotiable from your or the publisher's perspective. While every point memorialized in a publishing contract is important, the following outlines some of the major points to consider, as well as some other complex issues surrounding this stage in publishing your book.

Liability

As author, it is likely that you will be required by your publisher to assume all liability involved with bringing your book to market. What does liability mean? If there are recognizable people and/or trademarked property—for example, *The Simpsons* on a television set in the background of your picture—you may have to guarantee the publisher that you have obtained all necessary permissions from the

Martin Roemers, *Relics of the Cold War*
(Hatje Cantz, 2009)

copyright holder. If you include existing text or illustrations other than your original works, again, you may be required to release the publisher from any liability resulting from publishing these elements in your book. This is an area in which you need to be extremely well organized. Be honest with your publisher about the authority you do or do not have to publish the content featured in your photographs or contained in any of the contribution materials.

Production Schedules

Publishers generally have several projects in production simultaneously, and to keep things running smoothly, schedules are made months in advance. For example, promotional materials need to be made and disseminated, press time must be scheduled (with financial penalties imposed by the printer for breaking a press schedule), and the book must be presented at in-house sales conferences. Be sure to keep a calendar and promptly meet your responsibilities. If you miss a deadline for delivery of manuscript, scans, correcting proofs, and other key steps toward the final product, you may risk defaulting on the contract completely.

Advances and Royalties to the Artist

In the fine-art-photography-book-publishing world, advances—money paid to the photographer to secure a contract—are rarely paid. In modern terms, there are generally two types of photography books: a "theme book" is one that has a broad audience due to the subject matter (e.g., villas in Tuscany, NASCAR racing, or the Iraq war); and a fine-art monograph, which is one that presents you as the artist primarily, and the subject matter secondarily. This categorization is not

Publishing gives one the opportunity to learn and study while working. Every book is a new adventure, and all the people we meet and work with are part of that trip.

Markus Hartmann publishing director, Hatje Cantz

intended to imply that theme work and fine art are mutually exclusive types of publications, but to simply draw a distinction in the intended audience for a book. Advances are more common, though not mandatory, for the former, and extremely rare for the latter. This is due to the expense and the limited nature of the audience of an artist monograph. There is always the hopeful circumstance of having a block-buster title on your hands, but more than likely, the audience for you, as an artist, will be small. In talking with publishers, many agree that the average art monograph print run is three thousand. Many photography-book print runs hover around this number.

Royalties, while calculated in the past based on a percentage of the purchase (gross) sale price, are now more typically set based on a percentage of the net proceeds the publisher is left with after all related expenses are deducted. Since royalties are directly tied to the promise of sales and therefore depend on established markets, it is unlikely you will be paid a royalty by the publisher based on your reputation as an artist. Be informed before signing as to how, in percentage terms, royalties owed to you will be calculated, if they are part of the contract at all.

Payment Terms/Schedules

Most publishers have standard, company-wide payment schedules in place, which are nonnegotiable. Often, there are strict policies regarding the deduction of expenses from royalties paid; if not clearly defined in the contract, seek clarity on this issue of your expenses that are eligible for reimbursement.

Free Copies

Negotiate with your publisher to receive as many free copies as you can get!

We are looking for two things in a book: the quality of the work and the resonance of the work with our larger list. In the end, though, it's the ineffable intangibles that help us decide among the many projects that we see.

Theresa May editor-in-chief, University of Texas Press

―――――

Beyond that number (10–100) you will want the right to buy as many additional copies as possible directly from the publisher for as little as possible (often 40 percent off retail price). Clarify with your publisher as to whether you will then have the right to resell these copies to family and friends; at personal appearances and events such as lectures and workshops; and to independent bookstores or via your website. You don't want to be in violation of your contract, competing with your publisher on sales. (It is unlikely that you will receive royalties for the copies you receive or purchase; confirm this with your publisher.)

Rights Granted

Many publishers will ask for the authority to license and/or sublicense all or part of your book in other "for sale" formats and other languages. This could take the form of posters or note cards and abbreviated or lower-quality versions of the book for smaller markets. The most important thing to recognize here is that if you grant the authority to your publisher to pass on this right to a third party (to sublicense) you will be out of the loop on any and all decisions they may make. Many publishers ask for these rights but never exercise them, as they are not part of their core business. If you feel this is the case, simply ask to delete them from the contract. Conversely, you may wish to simply retain the authority to decline such grant of rights, or approve quality of production on a per-situation basis. In this case, you may wish to include "with prior permission of the Author" into these key sections of your contract.

Remaindering

When a publisher declares a title out-of-print, there may still be large numbers

O. Rufus Lovett, *Kilgore Rangerettes*
(University of Texas Press, 2008)

of your book in their warehouse. Often, these copies are sold at a great discount to a company called a remainder house, such as Daedalus or Texas Bookman. They purchase the remainder of the print run for very little money and sell those copies at a greatly discounted retail price. You, the photographer, will want to have advance notice in order to buy any or even all remaining copies before they are sold to a remainder house. When negotiating this issue, be sure to build in enough time to raise the funds and deliver the cash—in other words, a long lead time of at least two months (or more, if you travel often). Buying copies of your book at cost is to your advantage in many ways—these books can be your best promotional tools, used to introduce your work to industry professionals, secure exhibition opportunities, and more. They make wonderful gifts for collectors, and if permitted contractually, can be sold at lectures over the course of your career. The last thing you want is to find out from friends or others that your book is now available for $9.95 in the bargain bin!

Lawyers

While most of you will be comfortable with a review of the contract by your family lawyer, he/she may not be a specialist in visual-arts licensing and may not spot things that could be of great importance to you over the full arc of your career. Legal issues vary immensely from industry to industry—consider spending an hour or two with an attorney who specializes in working with artists or photographers. State arts organizations such as the various chapters of Business Volunteers for the Arts can often provide advice, as well as reliable referrals if needed. And don't forget to seek the advice of your peers who have publishing experience—they can lend valuable insights and advice.

Books can be large or small in their ambition. What is essential in my acquisition strategy is whether a book's content presents significant new or important information.

Patricia Fidler publisher, art and architecture, Yale University Press

———

Additional Costs to the Artist

As with mounting an exhibition of your work, the costs to you as the author of a book can be more than expected. Both are forms of promotion and should be seen as a major investment in your overall career. If you can negotiate some production costs to be paid by the publisher, or ensure that your expenses will be reimbursed, that's great. Know too that if you want to have a strong voice in the design and production of your book, you may have to pay for that control.

The following items are typically the author's expense:

— Fee for a book designer, if other than the person provided by the publisher
— Expenses associated with a nontraditional trim size
— Costs related to upgraded paper
— Untypical printing and binding of the book, as well as slipcases or other enclosures considered to be nonessential
— Fees to contributing authors or illustrators, whether commissioned or reprinting existing material
— Cost of prepress work for the creation of digital files
— Fees to copyright your work and any original work of contributors, if applicable
— Costs (including shipping) of providing you with a second set of corrected printer proofs

Lastly, as discussed earlier, it is unlikely that your publisher will commit to an extensive promotional campaign for your book, so plan on being a partner on these efforts, and absorbing some, if not all, of the costs.

| Laura McPhee, *River of No Return*
(Yale University Press, 2008)

Ancillary Products

The market for ancillary, or additional, products created with the photographs in your book, or "paper products" as they are often referred to in publishing contracts, is one that many photographers choose to pursue, as the potential revenue from such licensing agreements can be significant. Ancillary products include everything from note card sets to calendars and posters, and any other products related to your book. Some book publishers produce ancillary products in-house, either at the launch of your book or to extend the publishing life of its content, while others sublicense these rights to other companies.

When researching whether or not to pursue this market, the first step is to gauge a company's production values, such as the type of paper and card stock used, the quality of the printing, the branding and style of the packaging and design. Do this by simply looking at their products on the shelves or online. Ask yourself if this is a market segment that you wish to exploit, or not. Only you can answer that question.

Our Best Advice

Read each line of the contract, understand what every word means both individually and within the context of the full sentence, and determine your deal-breaking points ahead of negotiating the contract. In other words, know what you are and are not willing to budge on. Be sure you are comfortable with and completely informed about the language of anything you sign. No matter what the outcome, the process of walking through the steps to a signed contract will be education that will serve you throughout your career as an artist.

INDUSTRY VOICES

———

Nancy E. Wolff partner, Cowan, DeBaets, Abrahams & Sheppard LLP

Commonly misunderstood areas in a publishing contract include the granting of rights and the calculation of royalties. When you enter into a publishing agreement with the publisher, you retain copyright to your work but you grant the publisher the exclusive right to publish the work in book form for the life of the copyright. In addition to granting book rights, the publisher acquires many other subsidiary rights or the right to represent the work in other markets. These rights include serial (magazine), translation, book-club, reprint, anthology, excerpts, microfilm, dramatic, film, broadcasting, television, and merchandising rights.

The other area that is confusing is the royalty section. Payment is usually based on an advance against royalties. (Advances have not increased significantly over the years and have even gone down with some publishers.) At one time, royalties were calculated based on the retail sale price of the book. Currently, most publishing contracts include royalties calculated on the net proceeds a publisher receives from the sale of a book—many books are now discounted and are not sold at the retail price. The royalty based on net proceeds is essentially half of what the same royalty would be based on the retail price: if you want to receive 5 percent of the retail sales price of a book, you need to receive the equivalent of 10 percent of the net proceeds.

Another important point is to carefully review the rights granted, including the subsidiary rights. Because of Internet distribution, most publishers now demand publishing rights throughout the world, rather than in limited territories. (This has changed from twenty to thirty years ago, when it was once common to only grant English rights in limited territories and retain rights in certain territories.) Most publishers insist on retaining the first serial rights. (Serial rights grant the publisher the license to reproduce

short sections of the book, typically in magazines, either prior to publication, the first serial rights, or after publication, the second serial rights.)

Other rights to be mindful of are electronic rights, dramatic rights, and merchandising rights. If an artist has plans to do a documentary on the same subject or has a print- or paper-product business, it is important to retain dramatic and merchandising rights. Some publishers may want merchandising rights if they plan any companion note cards or calendars.

In addition, publishers will want the right to use the images for promotional purposes. I generally try to limit the number of photographs used for such purposes and have an agreed-upon preselection. The publisher will want to promote the book and allow the use of the photographs for free. If you have a licensing agent or earn a portion of your money through stock sales, these promotional uses can compete with your licensing income.

I would also read the out-of-print clause very carefully. Because publishers can now use POD services, they can maintain a book in a back catalog without having to maintain a large inventory. Under these circumstances, a book might never go out-of-print and you would never regain the rights even though there may be minimal sales. I would recommend that there be a monetary trigger that would permit you to consider the work to be out-of-print if a certain sales level were not met.

You should always be mindful of the no-compete clause and make sure it is very narrow. You would not want to be prevented from publishing another book because the publisher might think that the subject matter is similar. You should also ensure that you always have the right to license individual photographs that are contained within the work.

To Be Published or to Self-Publish

FOR MANY PHOTOGRAPHERS, THE TRADITIONAL PUBLISHING PROCESS CAN SEEM both inscrutable and overwhelming. Self-publishing may be the answer. Collaboration is essential to the success of any book, and if you decide to self-publish, you will quickly come to realize that the assistance of professionals at every stage of the process is key. We have outlined, up to this point, the various stages in the publishing journey, and you may want to consider the following points before deciding to self-publish. The differences and the overlap between either being published and working with a publisher or self-publishing can be seen from two distinct perspectives: the business side and the creative aspect.

Working with a publishing company involves working with experienced professionals in order to make the book a success. You must be prepared to work collaboratively, which necessitates compromise in certain areas. The book is not just yours alone—it is also a part of a company with a brand and a mission. Traditional publishing can generally bring your book to a much wider audience than you will single-handedly be able to manage, and your book is part of a much larger identity.

To self-publish is to take all of this on yourself. To build a team, you need to identify and manage individuals that will contribute at specific stages in the publishing process and who are hired to carry out your vision for the book and also to help market it. Successful self-publishers are those who are organized and entrepreneurial at heart, who know their audience, can effectively reach that audience, and have the financial and labor resources available to take on numerous roles.

As a viewer, I want to be involved and challenged and left with a sense that a dialogue is ongoing even after I put the book down. Questions remain but I can trace them back to the book and continue to be engaged and surprised.

Raymond Meeks photographer and book artist

———

To Be Published

Let's look a bit more closely at each of the two scenarios. As we discussed earlier, to be published, whether by a small art publisher or a large international publishing house, involves working with a group of people who are charged with helping make your book successful. In the best-case scenario, this team effort is a positive experience, undertaken with knowledgeable and experienced publishing professionals, who will bring your book into existence and promptly into the hands of thousands of appreciative readers. One thing is certain: for a publisher to undertake the traditional publication of a project, it must bring in more revenue than the cost of bringing the book to market, and hopefully have strong potential to continue to sell for many seasons ahead.

The types of projects that appeal to traditional publishing houses typically have a subject other than you and your artwork—unless you're a celebrity with a following. The ideal project will have a subject that already has a defined audience, and better yet, an audience to which the publisher has a history of selling books—existing customers are always likely to purchase more books on a topic in which they already have an interest, or from a publisher they trust and appreciate. If not convinced that your name and your work alone can sell thousands of books, a publisher will likely consider your project more seriously if an expert in your subject area will endorse the book by contributing a piece of writing for the book. In other words, unless you are already considered a household name, your proposal will be judged by the subject matter and the reputation of your contributor(s).

When published, your book will be a part of a bigger list of titles released by that company during that given season, and you will need to work toward being

Rose-Lynn Fisher, *Bee*
(Princeton Architectural Press, 2010)

memorable among that roster of authors and titles, all of which are clamoring for the attention of the in-house marketing and publicity staff. When it comes to the business side of things, larger publishers have buying power when negotiating with printers, allowing them to economize on paper, printing, and binding costs, as well as other materials. They can also secure time on press for several titles at once, giving them contractual leverage and bargaining power.

Smaller and independent publishing houses typically cover a narrower subject category and have a more predictable audience cultivated over the years. You may not necessarily be a household name to their audience, but if genre, artistic process, or subject matter falls within the publishing company's niche, the small publishing company will appreciate the value your book brings. With very little staff overhead, small publishers are able to, and must, function more nimbly and often more efficiently. It is likely that staff members have responsibilities in multiple aspects of the publishing process, and are therefore intimately involved with you throughout every stage.

Marketing budgets within publishing companies vary from title to title. Most of the midsize to larger publishing companies will initiate a standard marketing plan, which may include taking out some print advertising in relevant magazines and journals, as well as setting up book signings and sending out a certain number of review copies.

From the creative angle, midsize to larger publishing houses are likely to have one or several in-house designers who are busy with multiple titles at a time, making the possibility of long, intimate design sessions between you and them unlikely, if not impossible. This may make you nervous, until you realize that designing books is their profession, and they do it routinely. You can often work with a

As an editor, the biggest compliment is a reader who says, "I never saw that until I read your book, and now I see what you mean." It's a process of mutual discovery, like showing something really interesting you just discovered to a friend.

Jennifer Thompson editorial director, Princeton Architectural Press

———

freelance designer of your choice, who will provide the level of attention and quality you need, but it is likely that you will be responsible for the design fee, or at least a portion of the total cost.

The production calendar for your title is likely to be very tight, without much allowance for delays on your end in the delivery of prints, scans, or any of the contributing materials. It is increasingly common that printing is done outside of the United States, but regardless of locale, changes are costly and complicated on many levels after the book files are released to the printer. It is more likely—although not guaranteed—that you will be more directly involved in creative decisions when working with a smaller publishing company.

In short, when you are published, the decisions to be made and the ultimate responsibility for the book rests with the publisher and the team of editors, designers, and sales people that have been assigned to your project. The book is filled with your work but is part of a larger picture that is the vision of the publishing house. This is vital to keep in mind. On the other hand, you will be working with a team of experts who do this on a daily basis—a wise editor will shape your text and image content, a skilled manager will oversee design and production, experienced publicists will handle publicity, and the sales personnel will ensure that your book is well distributed. When an experienced publishing company produces your book, you are not forging ahead alone at any step in the process but rather working with a team of professionals with a range of expertise and experience.

Joel Meyerowitz, *Legacy*
(Aperture, 2009)

To Self-Publish

The single greatest asset of self-publishing is that you have ultimate control every step of the way. It will be your decision and yours alone to say yes or no to each question along the path of your publishing journey. You can work with the designers you choose, print on the paper you select, reproduce your work in the manner you feel is most appropriate, and make only those compromises you elect to make. You can produce the trade and limited editions to fit in with upcoming exhibitions, and you can market the book on whatever platform(s) and in whatever format(s) you prefer, directly to your targeted audience. You can create your own team of experts with whom to collaborate on each and every phase of the publishing process.

With self-publishing, there is no question that you have the greatest possibility of ending up with exactly the book you envision. What you may not have is the experience and skills to ensure you will achieve all that you want, from editing and design to marketing and distribution. It is important to underscore this point: the learning curve with any first publication is huge. You are doing alone what an entire industry is set up to handle: you make all the decisions (and reap any profits); you also pay all the bills. In other words, you get the book you want, but you will pay up-front for the cost of each aspect of the publishing process, hoping for financial return from the sales of the book and, ideally, any subsequent sales of fine prints associated with the book. You will need to address sales and distribution efforts early on to ensure that the entire shipment of books won't be housed in your garage or apartment. Special sales of large quantities of your book should be pursued with special interest groups or related corporations and nonprofit organizations. This can happen early on, even before the book is printed. Anyone that has a connection to

Thoughtfulness. This is the key ingredient to making a really great book of photographs. There are a lot of very serviceable formulas for bookmaking and design, but none of them should be adopted without thinking them through. A truly great book, no matter how simple its approach to form and design, rewards careful and close attention over time.

Lesley A. Martin Publisher, Aperture

the subject matter or the project is a potential partner when it comes to sales and exhibitions.

You should have a plan not only for marketing the book but for the marketing of any related exhibitions as well. You'll want to act like your own best publicist regardless of whether you retain someone to assist with promoting the publication or not. Publicity involves contacting and interfacing with magazines and the media, including online media, and utilizing both online and real-time social networks.

In short, the skills needed to successfully self-publish are extensive, from design and production of the book to business expertise, with a dose of project management thrown in for good measure. The many hats you will wear include editor, book designer, prepress manager, print production manager, shipping agent, distributor/ sales manager, and publicist. Any of these tasks can amount to a full-time job and thinking through the logistics ahead of time is crucial to your success (and sanity!).

Print-on-Demand, Zines, and the Digital Revolution

Perhaps the most revolutionary tool made available to photographers (and all aspiring authors) in the last few years is POD technology. Through high-quality digital printers, such as the Indigo printer by HP, books and magazines of remarkably professional appearance and quality can be printed one at a time—you can literally print a single copy as needed.

Producing a book (or a magazine-like object) that approaches the quality of offset printing and has the appearance of a professionally produced product has, until now, been inaccessible to most people because of the costs involved. Offset lithography, the predominant form of photographic reproduction in color, requires the production of plates from which the reproductions are printed. Set-up and print-production costs are extremely high and necessitate the printing of a certain quantity, often at least five hundred to a thousand copies; most printers won't accept a job for a lower quantity.

POD technology utilizes digital technology and circumvents the need for plates, eliminating the expensive set-up costs. Companies like Blurb, Fastback Creative Books, Editions One, Shutterfly, MagCloud, and AsukaBook (among many dozens of companies now employing the technology) are the leaders in this field and have actively targeted the fine-art-photography community.

This technology can best be utilized in two distinct ways. First, it allows photographers who are interested in the traditional publishing path to create a high-quality maquette that can be submitted to a publisher as part of an official proposal. Editing, sequencing, layouts, and text treatment, along with different cover designs are all easy to adjust, and for a relatively low price, multiple versions can be uploaded and printed at any given time. Producing a maquette early on can

| Rafal Milach, *Black Sea of Concrete*
(self-published, Blurb, 2009)

also greatly assist in the early stages of the development of the concept and content of a book project.

The POD book or magazine can also be treated as an end product. They can be printed in a small edition and sold as a collectible piece. This can work particularly well for small bodies of work that may have a very limited audience. Some photographers have taken this brand-new technology and melded it with a retro, handmade aesthetic, creating hybrid books that have POD printed interiors with unique or limited-run dust jackets and enclosures, like clamshell boxes and slipcases. Numerous photographers are producing their own zines—underground, under-distributed, limited-run magazines—using POD technology. POD books or magazines also make great promotional tools, serving as "leave behinds" for art directors and galleries that may consider taking you on as an artist.

It is a new era of book production as well as book reading. Clearly, POD offers authors affordable production and flexibility in the process of creating new titles. But technology is rapidly moving forward through great change. A book is no longer simply a three-dimensional object; rich multimedia-enhanced, multiple-language content that is readable on a new generation of mobile devices, such as the iPad and the Android, will forever change the experience of reading. These changes are termed EPUB 2.1. Many trade publishers are bundling the enhanced version of trade books with traditional print versions for an additional fee, or selling the EPUB version as a stand-alone product. Authors should explore how multimedia can expand the experience of their book, and secure the content and related rights for this new model. With multiple formats being considered by many publishers, it is an exciting period of invention that can benefit photographers and authors.

INDUSTRY VOICES

Eileen Gittins CEO and founder, Blurb

What drove you to found Blurb?
EG: Personal pain. I was trying to produce a book of my photographs to give to about forty people as a gift. This was in 2003. I went online looking for a Blurb-like company but all I found were nascent companies that offered lower-end photo albums. I looked hard for a company like Blurb, but I couldn't find one. So I started it.

What do you think is the most exciting thing about POD technology?
EG: It offers a whole new approach to the very notion of how a book comes into being. If you no longer need to predetermine the print run, sell a minimum of ten thousand copies, or warehouse them—then I think we are talking about an expansion in the book industry the likes of which we have never seen before.

Blurb both facilitates the printing and the selling of POD books. How do you think that will reshape bookselling?
EG: Bookselling in the twenty-first century will be about helping the author find his or her natural audience via the Internet and through various in-person and online social networking communities.

| Selection of POD books

INDUSTRY VOICES
——

Daniel Milnor photographer

About a decade ago, I considered self-publishing. At the time there was a real aversion to it. But in the last year and a half, there has been an almost complete reversal. This was the mid- to late nineties. I started out making prints on an Epson EX printer and had the pages laminated. They were great at first, but it was a labor-intensive process, and the prints simply didn't last. The next thing I tried was to make 4 x 6 ink-jet prints and take them to Kinko's to be spiral bound. Again, it was just too slow, too labor intensive, and too expensive. Scenarios like this kept happening over the course of the following decade until my wife came home from a photography trade show with a flyer for a company called Blurb. I grabbed a folder of image files, imported them, made a book, and sent it off to get a sample, to see what would show up in the mail. A week later, I had a great book.

I started making POD books nonstop after getting an over-the-top reaction from a client who saw one on my coffee table and said, "I want this book." I provide them to portrait and wedding clients and use them for my personal documentary projects. I've made about ninety books through Blurb so far. There are nine books available to the public, some of which are very quirky and would never be accepted by a mainstream publisher.

But that's part of the joy. You can make one just for yourself and never have to worry about taking it any further. For me it was fun, yes, but it was far, far more than that. It opened up an entirely new world for me and allowed me to offer a new product to clients. It also gave new life to my own work, which was the most important part. Through this process you learn how to shape your work into the book format. I can exist entirely on my own in terms of creating and publishing. The variety is endless, and so is the satisfaction. It has become the single-most-important development of the digital age, at least for me.

Selection of various small press, self-published, or POD books, clockwise from top left:

Sarah Wilson, *Blind Prom*

Nicolai Howalt & Trine Sondergaard, *Tree Zone*

Ed Panar, *Johnstown*

Daniel Milnor, *On Approach*

Phil Underdown, *Grassland*

Judith Stenneken, *Fotografie*

Frank Gohlke, *Thoughts on Landscape*

Carl Bower, *Chica Barbie*

Hank Willis Thomas, *Winter in America*

Mark Menjivar, *What Did You Eat Today?*

Jamey Stillings, *Colorado River Bridge, Hoover Dam Bypass v1*

Allison V. Smith photographer, self-publisher of zines

In 2006 I published my first zine entitled *Superficial Snapshots, Issue 1.* Three more quickly followed—in 2008 came *Issue 2, An Issue With Lomos,* in 2009, *Issue 3, Things I Like About Texas,* and in January 2010, *Issue 4, Can You Hear Me Now?*

I am a book-collecting, photo-loving photographer. I am constantly shooting. I shoot with my fancy digital for editorial and commercial work, but when I am just exploring the world for myself, I shoot with a variety of cameras, like my Hasselblad or Lomo or Widelux or my iPhone. I have my editorial and fine-art work, and then I have my "sketches." I needed a home for my sketches, the product of my other photographic side. They weren't website worthy nor begging for gallery wall space, so I decided to start making what are essentially self-produced magazines using the POD process.

I start by constructing paper dummies with a rough idea of what the final layout might be. In terms of the dimensions and page count, all three of these zines have been different. I usually start an idea and run with it. Designer Wendy Smith helps me with final layout and design. The whole process takes about two months, and I've used different POD services for each one. The first was flawlessly printed by psprint.com. The next two were small print shops in San Francisco. SuperPrint has been my favorite to work with.

I've marketed these zines on my blog and through Twitter, Facebook, and Flickr. The results have been overwhelmingly positive. It's given me real confidence with work that I had considered to be very rough. With each volume thus far, I've included a limited-edition 5 x 7 print for the first thirty people who order the zine. Once, I sold over forty-five copies of the zine in the first hour! Selling these limited-edition versions with a 5 x 7 print has helped me finance these little projects.

All along, I've made the zines for fun, for myself, as a means to play around with editing and sequencing. They aren't necessarily prototypes for future books, but they have given me real experience with the printed format.

clockwise from top right: *Issue 1, Issue 2,* and *Issue 4*

3

The Making of Your Book

Editorial Content

Firstly, [the book] should contain great work. Secondly, it should make that work function as a concise world within the book itself. Thirdly, it should have a design that complements what is being dealt with. And finally, it should deal with content that sustains an ongoing interest.

 —John Gossage, introduction to *The Photobook: A History*

The photographer and book connoisseur John Gossage offers this elegant synopsis of core principles surrounding photography books in the introductory essay to *The Photobook*. Making a work "function as a concise world" may be a tall order, but it is one that is achievable.

Photography books are complex beasts. That much we know. Having given a broad outline of the industry as a whole, of how books are acquired and who the players are within a publishing company, we'd now like to turn to the book itself.

There are three main stages to making a book: determining and shaping the editorial content, which forms the heart of the book, marrying that with a design that enhances the content without overwhelming it, and then working with a printer to physically manifest the final object.

The editorial content of a book is everything that has been gathered together by you and shaped under the guidance of an editor. This includes, of course, your photographs, as well as any text components, including essays, introductions, forewords, captions, afterwords, and possibly an index. Together, the images and the texts quite literally form the substance of the book.

Developing the editorial content is the first stage of making a book. Many of the decisions made further along the schedule come back to the decisions you make

We equate the development of a book to the architectural rendering and construction of a house. Once a book is fully developed and approved, we then enter a new phase of copyediting, design, and production.

George Thompson founder, Center for American Places

———

at this stage. Your book must be shaped around a central concept—either you as an artist and a body of work you've created or an independent subject that you've photographed. Once you have fully outlined this concept, it will guide how your content is shaped. The number of photographs and the sequence, the type of contributors you invite, the inclusion of back-matter material (such as chronologies and exhibition checklists) will all be determined by the central concept.

The concept will directly affect the physical specifications of the book. Many of the specifications are largely determined before and during contract negotiations. Generally, a publisher will work out a budget for a proposed book before offering the artist a contract. In order to determine the budget, basic elements like page count, trim size, type of binding, the number of color illustrations, and the reproduction methods are decided. Printers are then contacted and asked to bid on the book based on those specifications. The overall package can be adjusted slightly during the editorial phase, especially since content can affect color-production choices, the page count, and even trim size. Often these elements all come together during the editorial process.

INDUSTRY VOICES

Sam Abell photographer, *National Geographic* 1970–2001

Leah Bendavid-Val senior scholar, Woodrow Wilson International Center for Scholars; director of photography publishing, National Geographic Books (1991–2009)

As editor and photographer, you have produced ten books, four of them together. What is the history of your collaboration? How did you get started?

SA: Our long, rich, and searching conversation about books began the day that we met in 1990 and has continued without interruption since. The subject of the conversation has always been what constitutes greatness in a book and how to achieve it. We fueled our conversations with books, of course, but also included every topic from the daily *New York Times* to teaching long-range workshops on book publishing to photographers. When the subject is a great book, it seems that nothing in life is excluded.

Inevitably, we wanted to make the conversation tangible by collaborating on our own books. I was a staff photographer and Leah was an editor, both for the National Geographic Society. Our first joint effort was what they called an "institutional book" titled *National Geographic: The Photographs* in 1994. Working together on that book strengthened the idea that we could collaborate on more personal projects where the possibility for individual expression was greater. That led to three books published over the next decade: *Seeing Gardens* (National Geographic, 2000), *Sam Abell: The Photographic Life* (Rizzoli Publishers, 2002), and *The Life of a Photograph* (National Geographic, 2008).

How do you approach a concept and a body of work?

LB: *Seeing Gardens* describes our approach well. Sam had a vast body of work on the subject of gardens. He'd even done a book on that subject already (*Contemplative Gardens*, with Julie Moir Messervy, Howell Press, 1990). But he felt that straight garden-photography books are confined by their genre—they are about gardens and not photography. So he had no interest in yet another book of garden pictures.

Sam Abell, *Sam Abell: The Photographic Life*
(Rizzoli Publishers, 2002)

It seemed to me that the whole of Sam's photographic style was gardenlike. The same sensibility Sam brought to his garden work was in his photographs of wilderness and cultural landscapes. That realization led to the idea that a book could be created that began with literal gardens but expanded to include gardens of the imagination. What holds the book together is the constancy of Sam's eye and the expansive idea that gardens are all around us, even when no plants are present.

What has been the most satisfying book project thus far?
SA: *The Photographic Life*. The full retrospective autobiography is a really hard book to do. The subject of a life is so sprawling that it is difficult to wrap one's arms around. It may even be a book that shouldn't be undertaken. But Leah and I took it on because I wanted an expression of the path I had taken in my life for the benefit of young photographers. I wanted a book that was as much about process, mistakes, and choices as it was about successes. I wanted the book to be like life itself—beautiful and funny but also difficult. Above all, I wanted it to be honest.

I believe we made such a book, and it has a meaningful life. But it took us eight years to gather all the material and compose it satisfactorily. They were eight difficult years for me personally. If it had been up to me, the book would still be unfinished. But Leah kept the flame of the idea burning brightly during that time. Now when I think of the book, I think of the meaning of her loyalty to me and to our shared belief in the life of a book.

LB: I also love *The Photographic Life*. Working on it gave me a greater understanding of Sam's photographic aspirations and a deeper appreciation of his accomplishment.

Learning about his life has enlarged mine. During the years that we worked on the project, we talked about photography, about life, and about their mingling. We also talked about how to structure a very complex book. So the conversation at times was abstract; at other times it was practical.

The time we spent together and our conversations influenced the work we did. We got to know the material so well, including the layout and design, that we could talk on the phone about it without the work in front of us. The end result was a book and a process that was fulfilling. And it strengthened my desire to continue to work together.

I love our subsequent book, *The Life of a Photograph*. It opened the way to look at Sam's photography more purely. We took up the themes of his work without the biographical material or the framework of the assignments the work was done for. The themes and the book structure we came up with was the result of continual conversations until we reached a point where the book seemed inevitable to us.

Can you describe the collaborative aspect of putting a book together?
SA: For us, collaboration exists in two spheres. The largest of these is what you might call spiritual, and the core of that is a shared sense of trust. With a sense of trust in place, we feel we can converse with ease. This has generated a lot of ideas. Not all of them have survived, and some are very funny failures, but in a trusting atmosphere, we feel free to be honest.

The second sphere is the practical one and involves the nuts and bolts of how we work. The background of that is that we always have a lot of books around us. They exist as inspiring examples of accomplished work and also as examples of the structure and materials that go into making a lasting book.

We like to work manually. Every photograph that is a candidate for inclusion is rendered as a 2 x 3 low-res print. These in turn are pasted onto plain 4 x 5 cards. We each have a set of these, which can be organized and reorganized as the book evolves: candidates move in and out of the book, chapters are arrived at and arranged, and tone is taken up. This process can go on for months, but we always feel we're working toward the final book. When we're fully satisfied with the image selection and flow of the book, we sit down for the first time with a designer.

LB: We come to the design process with a philosophy that the design should serve the photographs. In the case of Sam's books, the uncropped photographs do not bleed off the page or cross the gutter. The layouts are not embellished with graphic devices. Sam's thought about design is to "allow the reader to see what the photographer saw."

Working with designers, production professionals, and printers is an essential and meaningful part of the process, and we stay involved until the book is in our hands. Then we start dreaming about the next book.

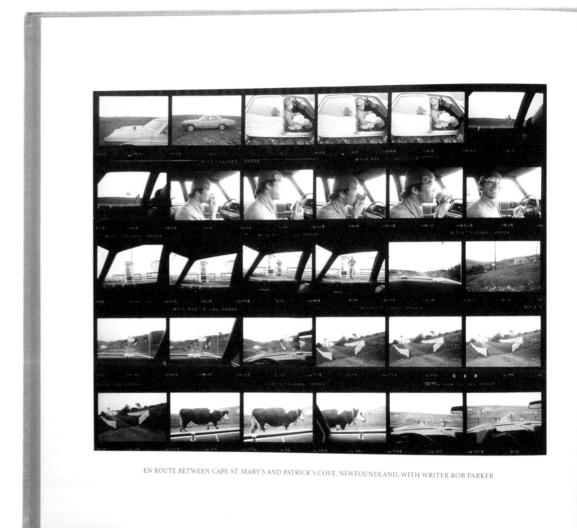

EN ROUTE BETWEEN CAPE ST. MARY'S AND PATRICK'S COVE, NEWFOUNDLAND, WITH WRITER ROB PARKER

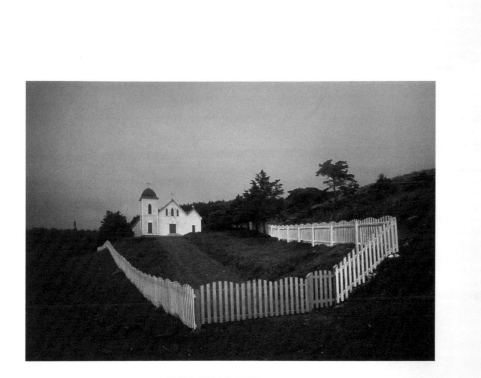

PATRICK'S COVE, NEWFOUNDLAND, 1970

INDUSTRY VOICES

Denise Wolff editor, Aperture

Generally speaking, photography books published for the trade market are not made in a vacuum, but supported by a whole team of people, who bring their own expertise and creativity to the project. The most important part of my job is to ensure that the strong and often differing opinions refine the book rather than tear it apart. In my experience this type of collaboration will take the book in directions none of us could have thought of on our own, which can be terrifying in its unfamiliarity for the photographer. Though, over and over, I've seen it produce the best possible books.

To clarify this point, I'll walk through the design collaboration that took place with *Winter Stories* by Paolo Ventura, published by Aperture in the fall of 2009. Paolo is known for the stunningly lifelike photographs that he takes of his handmade sets and figures. This collection loosely tells a story of an old circus performer looking back on his life. The photographs are witty, but often dark. He produces drawings of the scenes to help guide his set-making, which we really wanted to include in the book. But we knew that they needed a separate treatment from the work itself.

From the beginning, we knew we wanted to make a specialized boutique-type book in the $85 price range for a fairly small audience. The publisher tasked me to make the trim size as large as possible and suggested a horizontal format. Inger-Lise McMillan, our in-house designer, and I discussed this with Paolo before we began work on the design concept. (The design concept is an initial design that shows a variety of layout options, along with typography, text treatment, and overall look of the book.)

Inger-Lise and I tried several different horizontal formats and layout styles—without success. The vertical images were lost on the spreads, and the large size activated the white space too much, disrupting rather than sustaining the loose narrative thread we were looking to achieve. So we settled on a large portrait

Paolo Ventura, *Winter Stories*
(Aperture, 2009)

format, which afforded more variety in the layouts and allowed the pictures to fill the space in a more dynamic way.

The first concept nailed the picture layout, which moves nicely between larger and smaller, and from left to right. However, the typography and design details, though strong, were fairly generic. If I look at a design and can see that any body of work can be dropped into it, I know it needs to be pushed further, be more customized and imaginative.

The idea of silent film popped into my head for the book—the pictures could run like a silent film, and the drawings could be a kind of storyboard. Inger-Lise and I watched a lot of silent films to inspire us. We noticed that the films usually began with a paragraph describing the plot and included a flourish around it. She proposed that Paolo draw flourishes for the book—he is a wonderful illustrator—and do the lettering on the cover and title pages. She also came up with a special "Aperture presents" on the half title and ran a "The End" after the last image. She chose a classic Italian type from the period and placed the captions and folios high on the page to reference the high wire on the cover. In the drawing section, the folios move to the bottom of the page. Both sections are run with ornament versions of the font. These touches and details brought the whole product to life; the revised design manifested the central theme of the silent film beautifully without overwhelming the content.

We were ready to show the design to Paolo, though we were nervous because the new format was so drastically different from what we had previously discussed. It was also just a rough sketch of the wonderful idea and required a lot of imagination to envision. (Inger-Lise's drawn lettering was more like a scrawl!) Fortunately, Paolo quickly adjusted to the format change when he saw how dynamic the images became, with a

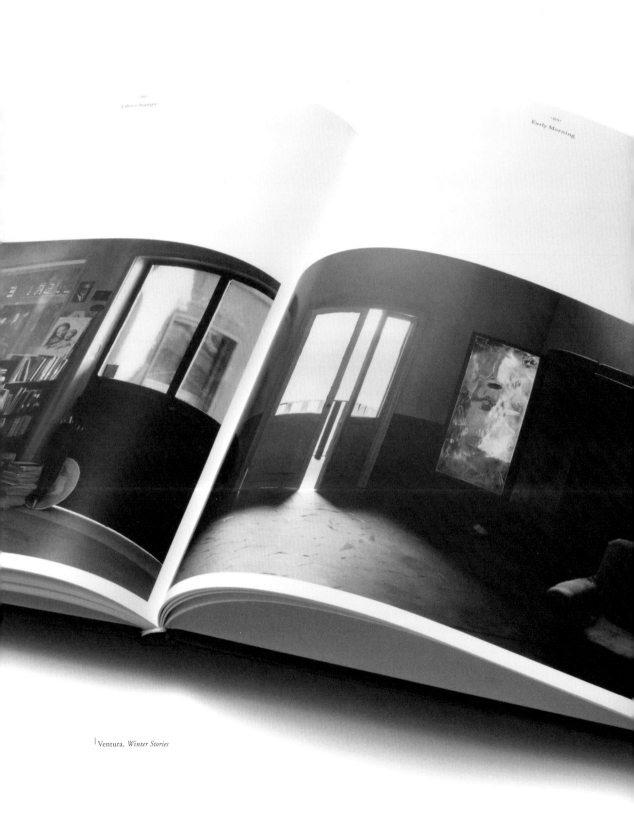

Ventura, *Winter Stories*

presence distinct from when exhibited, and appreciated the detail work of the concept. He also immediately embraced the idea of using drawings and returned two days later with a wide range of beautiful line drawings and letterings we could use. Ultimately, we used some of these in the final product.

While this is only one part of making the book, it shows how collaborating can bring the book to a place none of us could have imagined individually. Each person on the team made a worthy contribution to the project and brought out the best in each other, even when we didn't always agree. I think the fact that we were all open to ideas and allowed each other the freedom to play with the work shaped the product into something innovative and exciting.

INDUSTRY VOICES

Andrea Danese editor, Harry N. Abrams

So, you have a big pile of great photographs in your archive. That's terrific, but you don't have a book yet. Not by a long shot. If you're not as famous as Bruce Weber or Annie Leibovitz, far more thought and development of a concept is required before you show this pile of photos to book publishers. Let's say you've selected around three hundred photos that you believe are the best you've ever taken, the best representation of who you are as a photographer. What you need to do is sit yourself down in front of this pile, or the computer, and ask yourself the following question: Is there a theme running through the three hundred images I've selected?

Best-of monographs, unless you're very famous, rarely work any more. Instead, look for a theme of some kind—a theme with an audience is best—and focus on that. If someone brought us nature photographs, we would prefer ones that focus on a particular place or type of ecosystem or particular animal rather than a best-of group from around the world.

Now you've got a more selective, theme-based group of images. How do these images look together? Do they make sense together? Is every image top-notch or are there weak links in the batch? If there are occasional weak links, that's fine, but if there are too many, you need to rethink the idea. Do they tell a story? If yes, is it a narrative story that the mainstream audience cares about? If there's no story, what is their purpose? If it's purely aesthetics, then think about different ways you would sequence them. Which two or more photos would look good together on a single spread? Which group would look best on consecutive spreads? You want to put as much thought into this as possible before it goes to the publisher. When editors look at proposals, we ask those very same questions, particularly if it is a project people will want to buy and would be willing to pay $40 or $50 for.

Yann Arthus-Berthus, *Earth From Above*
(Harry N. Abrams, 1999)

At Abrams we look for projects that are unique and fresh and original, technically beyond reproach, about a particular topic that is timely or has a significant audience, and that capture the imagination and the eye. Nature is a topic that has generally done well for us, most especially our *Earth from Above: 365 Days* (1999) books. Now more than ever, we look for mainstream books with very large audiences, but a niche idea can work if you can prove that its audience is cultish and fanatical, one that will buy everything on a particular topic.

Design Considerations

THE FIRST STEP IN THE PROCESS OF DESIGNING A BOOK IS TO VISUALIZE HOW your images are going to function and look in book form. The research you have begun on books that inspire you, as well as the ones you dislike, will definitely have you thinking about what type of book you envision for your own work. Most photographers have a habit of organizing their work according to how it would look best on the wall and have not given much time or thought to the book as a three-dimensional object.

A book of photographs can work on multiple levels. The intent behind your photographs and your desire to publish them will guide this process. You may want a book that acts like a field guide to a particular subject, or you may envision a monograph that celebrates your artistic output. Documentary projects often have a strong storytelling component, and the choices made in the editing and sequencing of the work will greatly affect the overall force of the narrative. The overall experience of the work in book form is greatly different than in other settings, such as a gallery space or on a website, and a good designer will be sensitive to the impact the book can have on this experience.

Depending on the publishing route you have decided to take, you will be assigned a designer by the publisher or you may need or want to hire one yourself. When it comes to finding a designer, look locally. There are undoubtedly resources right in your hometown of which you are probably unaware. Inquire with local museums that have publishing programs and ask who they have worked with in the past (and would work with again). Check out local universities that may have MFA programs in Design. Ask around the art and gallery community for

AIGA, *365: AIGA Year in Design 29*
(Chronicle Books, 2009)

recommendations. Most cities have a local AIGA (American Institute of Graphic
Arts) chapter, which is an excellent place to start.

 Working with a designer can be the most exciting part of the process, precisely
because this is when the book starts to really take shape in front of your eyes! Many
publishers are known because of a style they have developed, and part of your
research about publishers involves an awareness of their design sensibility. Does
your work, and your own tastes, match that of the publisher you have decided to
approach? Likewise, if you have decided to hire a designer, you'll want to look at
their previous work to know if your tastes align.

INDUSTRY VOICES

––––––

Lorraine Wild founder and designer, Green Dragon Design

David Chickey and David Skolkin founders and designers, Skolkin+Chickey

Bob Aufuldish partner and designer, Aufuldish & Warinner

What are the characteristics of the ideal photographer/client?

LW: An open mind and the understanding that there is something to be gained through the collaborative process.

DC: An ideal client is somebody that has a specific point of view and recognizes the different roles that the people involved are there to play—and how best to achieve that as a group effort. It helps enormously if the photographers can articulate their intentions behind the work—this can help generate a design that makes innate sense. . What is the artist trying to say or express in the book form? Who do they see as their best audience? What kind of design are they looking for? Ultimately, the ideal client will understand that a professional team is an asset for getting the best end results.

What are the biggest difficulties for photographers when working with book designers?

LW: Photographers organize their portfolios or visualize their work on the wall, but rarely do they really think of the full range of possibilities for the representation of their work across the pages of a book. In a sense, it is difficult to gain enough objectivity; it is hard for the maker of any artwork to imagine themselves as the audience for the work.

BA: In general, the kinds of difficulties that develop are around diverging visions for the direction of a book project. But those issues can be avoided by having a good conversation ahead of time. That way, everyone knows what direction the project is headed before the design work really begins. If the book is not being self-published, there's the whole mechanism of the publishing industry involved—it's not just the designer that determines the outcome. The editor, the art director, the production manager, on through to the printer—all these participants have an impact on the finished book. There's a large team behind every project.

DS: The photographer must feel in sync with the designer. Working with a designer that doesn't "get" the work will only cause problems. Sometimes photographers have a hard time letting go. When the work is used for inclusion in a book, it gets reinvented. It will look different because it's presented in a brand new format. It is offset printed, which means the image is broken down into dots for reproduction, and will never look the same as the original print, though everyone tries their best to get it there.

What do you ask a photographer to bring or prepare for a first meeting?
DC: The work is the most important thing, but I always ask them to also bring copies of books that they like and, sometimes more interestingly, copies of books they don't like. I think often we're better at explaining why we don't like something than explaining why we do like something, so it's a different way to start a dialog.

It's important for photographers to find designers that have sympathetic aesthetic points of view. As much as we want to be excited to work with a photographer and their specific body of work, I think it's as equally important that the photographer be happy with the design of the work and feel good about choices and directions that a designer makes.

BA: If you have a thesis statement as to what the body of work is about, you'll be way ahead of the game. A thesis will help you make decisions about the book, from the editing and the sequence to the format and the design vocabulary. Otherwise, you're stumbling around in the dark. Also, the best way to make a book is to make a book. Look at it, learn from it, and make it again. For this process, making a maquette can be extremely useful.

Remember that design is an iterative process—you may not need a designer to work with you on your book, but you do need design. Your book can't exist in a design-less vacuum. Look at other books with a critical eye toward the whole of the book as an object and artifact. Look at and analyze everything about the book—the binding, the paper, the type, the printing quality, the size, number of pages. These details can go on and on, and all of them influence how your book—and your work—will be perceived. Look at the decisions made for the books you love and try to get at why those decisions work (or don't work). They'll help guide your decisions as you work on your own books.

What are the biggest misconceptions that photographers have when it comes to the design of their book?

DS: I think there are some photographers who think about the book form more than others—so some really drive the process, and others do not. A misconception can therefore come up over not knowing how involved they can be in the design process. Ultimately, the book is an expression of their work, so they should be integrally involved in the design.

DC: I sometimes find that photographers have different expectations than artists who work in other media. Painters and sculptors, for example, often start a book project with the perspective that the printed image on paper is a step removed from their original artwork. A piece of sculpture exists in three dimensions, and the reproduction of that sculpture in a book is clearly not the original piece (in fact it's often the reproduction of a photograph of that piece). In photography, however, we are reproducing an object that also started out as ink on paper. A photographer can have some

Britt Salvesen, *Harry Callahan: The Photographer at Work*
designer: Bob Aufuldish (Yale University Press, 2006)

David Maisel, *Oblivion*
designer: Bob Aufuldish (Nazraeli Press, 2006)

expectation that because their gallery prints are ink on paper, the book should be exactly like those. Technically, the book is printed in a different way, and so exact duplication is not really viable. The reproductions can get close, and in some ways can be a great and different way to experience the work, but they are a different form of ink on paper.

BA: That the designer will want to make the design overwhelm the photography is a big one. That any design whatsoever will somehow cheapen the work. That design will make the presentation less neutral—a kind of neutrality being what many photographers want these days. Again, my experiences working with photographers have been great. These observations are based on what I hear when talking with other photographers.

What is the most enjoyable part of the entire design and collaboration process for you?
BA: There are many delightful parts of the process. I like the very beginning when I'm first discussing a project, when the work is perhaps not completely formed. I love listening to photographers who can clearly talk about their work. I often immediately start seeing how the book might work from that earliest conversation. Once a conceptual direction is decided on, I also enjoy the time in the studio by myself as I'm working through design options. This is a very meditative process that benefits from spending time with the photographs.

Really, each part of the process has its own pleasures, and hopefully when the book is finished and the copies delivered, people who look at the book are transported by the photographer's vision, and the book has an inherent rightness about it that makes the presence of the book feel inevitable.

Introduction: Reimagining the Great Pl

[The Great Plains] is geology stripped bare, leaving
and land stretched out in long, sweeping lines tha'
horizon with a line that is sometimes so clear and
sometimes exists at the edge of metaphysics, or
summer or winter, blending into mirages and th
which wavers just the other side of the horizo
and grass, and what Nature leaves bare the

—SHARON BUTALA

The Great Plains of North America exists for me both as a physical lands
landscape. Geologically speaking, the Great Plains has a relatively unevent
ment turning to stone as one layer was added on top of another. An enorm
an uplifted seabed, the Great Plains began forming twenty to thirty million
spread across the continent by rivers of snowmelt and rainfall that flowe
Rocky Mountains to the west and by winds that raced unimpeded acros

1. As quoted in Diane D. Quantic and Jane P. Hafen, editors, *A Great Plains Reader*, "The Subtle
Press 2003), 32–33. Butala's essay was first published in David Landis Barnhill, editor, *At Hom*
(Berkeley: University of California Press, 1999), 165–79.

Joe Deal, *West and West, Reimaging the Great Plains*
designer: Skolkin + Chickey (C.A.P., 2009)

DS: The most enjoyable part for me is when I get emails from the artists saying they just received the advance copy, and it was just as they hoped it would be. That's the biggest thrill for me—feeling that the book has really satisfied the artist's vision.

In terms of the actual process of it, I think it's when I complete the initial design. I see the whole thing complete, and I see how it's going to lay out. When I'm hit with that inspiration, it's a very exciting moment. But there is nothing like getting a happy response from the artist.

DC: I agree with that. I think the most exciting part of the process is that moment after you've spent some time with an artist and some time with the whole conception of the project, when it really coalesces, when the designers and the artist begin to really see what it can be. That's a great creative moment.

Production Details

ONCE THE BOOK HAS BEEN DESIGNED, THE TIME HAS COME TO BRING THIS book to fruition. And while a book filled with one's photographs is the desire of every photographer, implicit in that goal is the desire to have a *well-printed* book. There's no worse nightmare than seeing your own photographs poorly reproduced. Everyone has heard horror stories about publishers cutting corners on projects or how pressmen kept adding cyan instead of subtracting it. Publishers and printers, too, have their own stories of unbending prima-donna artists, who arrive looking to extract an impossible exactitude from the press, unaware of the parameters and limitations of printing technologies.

In considering production issues, there are two stages: the prepress work, undertaken to prepare everything for the second stage, which is the on-press work. Many larger publishing houses employ a full-time production manager. These are individuals who often have decades of experience working within the publishing industry—sometimes as designers, sometimes as sales reps for printers—and have come to specialize in managing all of the issues surrounding the printing and bind-ing of books.

As your book is going through the editorial and design process, you will prepare your photographs for reproduction so they will be ready to send off to press. Photographs are reproduced in ink on a printing press via a printing plate that has been made from digital files of your photographs. Describing in detail the technical aspects of preparing digital files is beyond the purview of this book, but suffice it to say that it requires a level of expertise that most photographers do not have. But never fear! There are others that do. Many large printing companies both within the United States and abroad, have internal prepress departments.

Likewise, independent companies that specialize in just prepress work exist in nearly every city.

The goal of prepress work is to take your photographs and produce highly calibrated digital files that will print accurately on the printing presses. If you produce gelatin-silver prints from film, a good prepress company can either scan or photograph your original prints to produce a high-resolution digital file.

If your work is already in digital format, a prepress department at a printing house can give you the proper specifications for adjusting the files so that your work reproduces accurately. In either of these scenarios, it is best to have three identical sets of prints: one for the printer, one for you, and one for your publisher (or the production manager at the publishing company). These sets of prints will act as match prints, which the printer will use as a reference when generating press proofs. It is extremely important that the match prints be exactly as you hope they will appear in the book. This is because your original work is being reproduced with ink on paper by a completely different technology than however you produced your match prints. Printers are simply trying to get as close as possible to the match prints you provide, and the production manager's job is to ensure that happens.

A prepress department will take your digital files (or the ones they have created) and output a set of digital proofs. These are proofs from a digital printer that has been calibrated as closely to the printing press as possible. Your first color corrections will be made on these digital proofs. They are less expensive to produce than what are called wet proofs, which are printed on the actual paper of the book using the same press that will be used to print your job. These digital proofs are extremely accurate and afford the photographer and the publisher a

A variety of binding techniques for hardbound, softbound, and slipcased books

The blind spots of a project often occur in production. Photographers often assume the only good book is beautifully printed in tritone, when very often a cheaper, rougher printing will be better for the book and for communicating the message.

Martin Parr photographer and bibliophile

———

chance to review the work before it goes on press. Each set of digital proofs costs money, and often a publishing contract will include only one or two rounds of digital proofs. Once these have been approved, the next stage is to pull a round of wet proofs. This is the real deal. If the production manager is at the printer, he or she will oversee these wet proofs. If no one goes on press, then a set of wet proofs will be sent to the publisher (and sometimes also to the photographer). Slight adjustments will be notated directly on these proofs, and they will be sent back to the printer in order to proceed. The internal procedures of the production department may vary from publisher to publisher, but this outlines some of the general concerns and steps in proofing.

INDUSTRY VOICES

————

Sue Medlicott independent production manager

Can you describe the essence of what you do as a production manager?
SM: I work very hands-on with photographers, and my strength is in being able to
talk to a photographer about their work, to understand their work, and to then help
translate that vision to the people who actually have to *make* the book—the printers and
pressmen, and the binderies. There is a big gap between the artwork and the creative
process that made that original work, and how the information is translated onto the
machinery in a way that will render something that the artist is happy with. I act as an
intermediary between the conceptualized book and the finished, designed, printed, and
bound object. Ideally, this would be a seamless process, but there really is, and will
always be, a need for people who can speak both languages—the language of pictures
and the meaning of pictures and the language of how to translate that appropriately
into a book.

When a publisher hires you, what are you expected to manage?
SM: I am contracted to deliver a certain high quality of reproductions in the final, bound
book. I believe that in order to do that, it's all about preparation and getting the digital
separations right. There is a perception that certain printers and printers in certain
countries are better than others; on the level of individual craftsmanship, that may be
true. But if you prepare properly and provide the right type of separations and manage
the printer and supervise the overall process, you can literally print anywhere in the
world and get spectacular results.

Jeffrey Fraenkel, *Seeing Things*
(Fraenkel Gallery, 1995)

How do you advise a photographer and the designer about choices for materials?
There may be a design concept already in place, but the paper and binding hasn't been
decided. Now what?

SM: One of the most important parts of making a book is which paper is chosen for the project. I like to ask a series of questions about the subtle qualities one is looking to achieve in the reproductions. Is it something about the quality of light? Or the saturation of color? Is it the softness or a certain type of contrast? Is the light or mid or dark tones most important? I want to understand the expectations for the reproductions.

The relationship between the designer, the photographer, and the production person needs to be very tight. Then it's about figuring out who is going to make the separations and who is going to print the project based on another set of limitations, such as budget, timeline, and other variables. There are actually a lot of choices when it comes to printing and materials.

INDUSTRY VOICES

———

David Chickey and David Skolkin founders and designers, Skolkin+Chickey

When it comes to accurately reproducing original artwork, what do the printers you work with require?

DC: There are many different ways that this process can be carried out, depending on the artist involved and the preference of the printer. It can be more economical to use your own digital files, as long as they are of very high quality. There are professionals in the industry, like Thomas Palmer and Robert Hennessey, who specialize in digital scans, especially for black-and-white photography. Some printers, such as Cantz in Germany, prefer scanning from original prints. In other cases, publishers and artists may contract that work out to locally based prepress companies.

For color work, digital files provided in RGB format will need to be converted to CMYK format for printing. This process is best left to the professional who is prepping the files or to the printer. I never recommend that the photographer make this conversion, as there are just too many variables depending on the printer and the specs for the project. The same is true for black-and-white work printed in two or three colors. The photographer would need to provide either just the prints for scanning, or just grayscale high-resolution files. A professional or printer would then process these for duotone or tritone printing.

During the proofing stage, the printer will generally produce a set of proofs—either digital proofs, which are essentially color ink-jet prints that are calibrated by the printer to approximate the press conditions; or wet proofs, which are printed on the press itself, most often on the actual paper specified for the final book. Most color work is proofed digitally now, since this is a much more economical way to create proofs. Black-and-white work is often printed in duotone or tritone, and these files can not be proofed digitally. Therefore, these files need to be wet proofed.

David Scheinbaum, *Beaumont's Kitchen*
designer: Skolkin + Chickey (Radius Books, 2008)

If the original artwork is a set of 20 x 24 gelatin-silver prints, what are the steps involved for making digital files for reproduction?

DS: In the old days, both two-dimensional and three-dimensional artwork would be photographed as 4 x 5 transparencies, and then those transparencies were used to make the film and then the plates for each of the four colors (CMYK). That's still the case for many books. The only difference now is that those 4 x 5 transparencies are digitally scanned to produce files used for reproducing the photographs.

DC: If an artist can produce a set of prints at the scale they will be used in the book relatively easily, that is ideal. In producing that set of prints, they should be made as perfect as possible. Those prints become the hallmark that the prepress files and on-press work will reference. Everything else is built around those prints and the pressmen will try to match them.

These prints are then scanned by the prepress technicians on a flatbed scanner or by shooting them on a copy stand with a digital camera. Once the raw high-resolution digital files are created, various other decisions are made in regards to preparing those files: which printer will print the book, are the reproductions going to be in color, duotone, or tritone, which paper will be used, etc. This is work that requires specialized training.

Do you advise photographers to make scans of their work for reproduction themselves? If not, why?

DS: I would leave it to the experts.

DC: Ideally, the person that is creating that digital file is someone who has a lot of experience and knows what is needed for offset printing of every digital file. If the

VOLUME I

JULIE BLACKMON DOMESTIC VACATIONS

Beaumont's Kitchen

AT CITY'S EDGE PHOTOGRAPHS OF THE CHICAGO LAKEFRONT BOB THALL

LEWIS AND BELASCO the dissolve SITE SANTA FE

Photographers, Writers, and the American Scene
Visions of Passage James L. Enyeart

MICHAEL LUNDGREN *Transfigurations*

JOHN BALDESSARI A CATALOGUE RAISONNÉ OF PRINTS AND MULTIPLES, 1971–2007

The Spirit & The Flesh DEBBIE FLEMING CAFFERY

LEE FRIEDLANDER | NEW MEXICO

robert stivers

Selection of books designed by Skolkin + Chickey

photographer has that knowledge, then great. But often the photographer doesn't have that knowledge, and it's better to either work directly with the printer or directly with somebody who does, like a prepress house.

Is it necessary for the artist to be on press?
DS: It's not necessary. But if they really want to go on press, I think they should have the chance to do that. I don't think we'd ever let a photographer go on press alone—there would have to be a representative from the publisher with them because there are many decisions that are made that they may not be aware of. If the photographer goes on press, they need to understand that the final decisions about corrections are up to the designer or the publisher—or whoever is paying the bill, actually. Leave it up to them to make it all happen. I love having an artist on press, as long as they're not control freaks.

If you're not able to go on press, can you still be guaranteed of a good product?
DS: Definitely!

DC: Going on press is about fine-tuning—it's not the difference between having a horrible book versus a stellar one. Ideally, the prepress work was good enough that a good printer can produce the desired result. Going on press is about making nuanced decisions about the color of images that are falling on signatures with other images. An artist will want to make those in conjunction with somebody that is skilled at being on press and working with a printer. The entire process can be wonderful, but it often comes down to finances and whether the publisher can afford to have them there.

INDUSTRY VOICES

Mark Klett photographer and Regents Professor of Art at Arizona State University

How have you approached prepress work for your books?

MK: The publisher and photographer should combine efforts to find the best solution for the scanning process. You ultimately want the scans and final press proofs calibrated. In my first book the scans were all produced in-house by the publisher's design department, the cost of which were included in the total expenses of book production.

In this case, I brought a set of original 8 x 10 prints to the publisher. They produced scans directly from them, and we worked together on color calibration before going on press. This is the easiest route to take—give good prints to a good printer and have them make the digital separations. It takes a lot of time and experience to do this work yourself! And if you make the scans, you're responsible for their results on press, not the printer.

Photographers shouldn't generally take on the task of producing their own separations unless they know what they're getting into. It's not for those with casual interest in the process. There's a lot to learn, and after several books and one catalog, I'm only beginning to have a clue. Since most good printers have spent years doing this kind of development, you have to ask yourself if you think you can really do better. Are your skills up to the task? Will you really see a marked increase in quality?

With that said, there are lots of reasons why some photographers would want to make their own separations. If your work already exists in digital form, as was the case for me with *Yosemite in Time* (Trinity University Press, 2005), it makes sense to go directly from your files to separations rather than making a print, which would have to be scanned. You save that generation, and the reproductions tend to be sharper. And after I bought a drum scanner, I learned to make good scans from my negatives so they were sharper and cleaner than scans made from prints.

Mark Klett, *Saguaros*
(Radius Books, 2007)

I've been getting better at prepress work, and I think each book shows improvement. But I'm still tweaking my skills with duotone files, which are the most difficult to prepare. Almost any decent printer can do good color work today, but good duotones require being very accurate with the data supplied to the printer.

Unless you've got a lot of clout or a good subvention, don't look for the publisher to help you out on paying for third-party scans or even giving you a break on doing the work yourself. Due to the necessity of proofing, they won't be saving much money, if any at all. Also, most printers have minimized the cost as much as possible by creating a good in-house team, and their own price is often hard to beat in money or time.

4

The Marketing of Your Book

A Comprehensive Marketing Strategy

"YOU CAN'T SIT AT HOME AND WAIT FOR THE PHONE TO RING!" IS AN OLD ADAGE
that is particularly relevant when it comes to marketing a newly published book. If
you want your book to be seen and purchased, people must know about it.

What aspects of publicity should you depend on your publisher to perform,
and how can you, as author, best assist their efforts? Whether you're self-publishing
or being published, what are the benefits of hiring an outside publicist? How cru-
cial is an accompanying exhibition to the success of your book? What should you
yourself plan on accomplishing toward promoting your forthcoming title? These
are essential questions that we will address and for you to think about as you begin
developing your marketing strategy.

In order to best promote your book, picture yourself as a partner to the other
marketing professionals you'll work with, whether that is the in-house publicist,
a hired publicist or firm, the book critic at a national magazine, the arts editor at
your local newspaper, or the book buyer at a retail bookstore. Listen, learn, and ask
how you can help—they are your frontline advocates. Let them know that you are
happy to give interviews and to participate in any public forum. Provide polished,
well-designed, and well-written materials so that they have all the tools necessary to
properly introduce your photography book to the world!

Your publication date has been set! Congratulations. Now the work begins.
Publishers launch many titles per year, and when a book is considered a new title,
it is at the forefront of the minds of the marketing staff. However, the designation
"front-list title" usually lasts just for the season during which it is released, and your
book's release will be newsworthy for a relatively short period of time. The slate of
the next season's titles is never far down on the publisher's to-do list.

Each book has its own audience. With some books, the subset is much larger,
encompassing variously the environmental community, the human rights sector,
all women who have had breast cancer. Worlds within worlds connecting with worlds...

Nan Richardson publisher, Umbrage Books

———

A comprehensive marketing strategy can be divided into two phases—the
first phase is the time leading up to the launch date of your book, and the second
involves extending the life of your book beyond the publication date, ensuring
sales well beyond that first season. Many of the marketing tasks discussed here will
overlap these two phases. Your goal is to effectively promote your book to all who
are likely to be interested. It is important to make sure that the methods you adopt
in order to promote your book are both affordable and sustainable for the entirety
of its long life in print.

Timeliness in Your Marketing Efforts

Besides making a strong first impression, timing is everything with publicity.
When strategizing for your campaign, begin your promotional efforts sooner rather
than later. There is a lot to consider before, during, and after the launch of a book
as well as in mounting a marketing campaign. The earlier you get an overview of all
components the better. Set a calendar for all the deadlines as you become aware of
them, and make sure to adhere to the dates as much as possible. Timeliness in pub-
licity is everything; starting too early can peak a campaign prematurely, and starting
too late leads to missed opportunities and a shortage of momentum.

Monthly magazines typically have a three-month lead time for coverage, less
for their calendar listings of events, such as lectures and book signings. In addition
to editorial and/or critical mentions of the book, the cover and additional images
could also be featured. You should carefully target those who will be most recep-
tive to you and your subject, and approach them about featuring your book well
in advance of your date of publication. If your promotional presentation is well

designed and enhances your work, you will have a stronger chance of securing not only press for your book but the possibility of accompanying picture essays in print journals and magazines. Holidays can also offer additional marketing opportunities to pursue.

The all-important "Best Photobooks of the Year" articles that many print, and web publications release, at the end of each year should be carefully planned for so as to not miss a deadline. Be sure you take the time to inquire as to whom and by what date your publication must be submitted for consideration in these essential lists. Begin compiling details surrounding the year-end lists now so that when your title is ready, your contact list is in order, and your books can be considered for such accolades in a timely fashion.

Maintaining Relationships and Building a Mailing List

Throughout the process of producing the work for your book and search-ing for a publisher, you will form many new professional relationships. You will undoubtedly meet many people who are fans of your photography and potential buyers of your book, but there are also many professionals—writers and critics who express interest in your project, booksellers, magazine editors, bloggers, festival directors, curators, and collectors—of whom you should maintain itemized contact lists. Archive the contact information and maintain a meticulous mailing list that includes both street and email addresses. Many mailing lists allow you to categorize contacts, and this is a good habit to get into.

You can build an initial mailing list from online resources and first-person research at libraries and newsstands. You can also purchase media mailing lists of

left and opposite page: the book and press packet for Arthur Drooker, *American Ruins* (Merrell, 2007)

the key people who produce radio and TV/Cable network shows across the country. We all know what happens when a celebrity mentions a book or has an author appear on the show: book sales! Be mindful of gathering testimonials about your book and the overall project, and ask for permission, in writing, to use those statements on your book's website and in promotional material.

Budgeting

Creating a budget that can support a comprehensive marketing strategy can be a challenge, and it may be easiest to start with a set amount that you can afford. Carving up that amount in a wise and efficient way that best supports your book should be your goal. If you plan to print promotional pieces, launch a website, attend portfolio-review events, or make personal visits to secure exhibition venues, make sure these expenses are planned in your marketing budget or that they are part of the marketing budget of your publisher. If funds are limited, be sure to plan only what you can afford and implement strategies that you can truly sustain. While still striving to reach broad and diverse audiences, be sure to research less-costly options such as targeting a specific group of bloggers, utilizing social networks like Facebook and Twitter, utilizing local venues, or producing a small quantity of promotional mailers at home rather than spending money on an expensive, professionally printed object.

Branding and Identity

Building awareness for the book begins the moment you make the commitment to publish a book. There are two very important aspects of any marketing

The most important element is the proposal, the thoroughness and eloquence of the case that's made for the project. That's what will gain an editor's confidence and give them a sense of safety that what's being promised is what will be delivered.

Scott-Martin Kosofsky principal, The Philidor Company

———

campaign. The first is to make sure that your promotional materials plainly state your objectives and are clearly written with your targeted audience in mind. The second is your branding, by which we mean a continuity of presentation and graphic identity. These two elements should be in place in all elements of your promotional materials.

Your book cover can serve as a default logo for a marketing campaign, and certain aspects of the cover design, such as a font used on the cover, can be extrapolated into an overall identity. The cover image or the font can be used throughout the marketing and promotional pieces you will create in print, such as letterheads, brochures, and mailings, as well as for online use, such as on blogs and websites. The printed pieces you create—no matter what scale, quantity, or format—should all have the same consistent look as the book. Maintain this graphic identity throughout the design elements in color, fonts, logos, and symbols— online and in print.

If you elect to retain the services of a graphic designer, web designer, or web programmer to establish your business identity, it is essential to clearly understand their role in the design and production process, as well as your responsibilities as their client. Budget, deadline, ownership issues, and subsequent costs for updates to the site, must be clarified in advance of signing a contract and commencing production. Your most important responsibility in this process will be to clearly communicate your business model and professional goals. Help these professionals create tools for you that can expand to accommodate your growth as an artist and the evolving life of your book: press and testimonials, audio/visual clips, print and limited-edition acquisition information, exhibition details and installation views.

It is essential to determine in advance how much the publisher is prepared to do and have an independent publicist come on board. The publicist can start sooner, work longer, and generally do more than most publishers have the time or staff for.

Joanna Hurley founder and president, Hurley Media

———

You will save time and money by imagining and planning for the full arc of your career and by presenting memorable, consistent promotional pieces for your book.

Working with a Publicist

If your photography book is being released by a traditional publisher, it is likely that they will have an in-house publicist whose responsibility is to promote the entire season's list of books. Whether you work in tandem with this person and/or decide to invest in the services of an outside publicist, you should be in close communication to clearly define responsibilities as the launch of the book approaches. It is important to know precisely what you can expect from an in-house publicist and what is in turn expected of you in order to ensure that all markets are informed of your forthcoming publication.

If you decide to self-publish, you will want to look seriously at the value of obtaining professional assistance. For example, some authors hire a public-relations person to develop and pitch a fine-print exhibition to accompany the book project—a task that is not normally the responsibility of an in-house publicist. Others may have relationships in print media, but look to a publicist to help with securing mentions in television and/or radio. If you decide that even more effort should be made to market your book, survey several publicists and their previous successes to decide whether retaining their services will be an asset to the overall marketing campaign. Regardless of whether you will have the assistance of an in-house publicist and/or retain a professional to help promote your book, you will be your own best PR person. This is no time to be shy. Clearly and emphatically announce your project to the world, and, most importantly, to *your* world of contacts and networks.

I think to showcase your work brilliantly on a website is crucial from our standpoint and is much more likely lead to a publishing project than submitting a fully formed concept. We look at endless photographers websites for work.

Geoff Blackwell founder, CEO and publisher, PQ Blackwell

———

Preparing and Mailing a Publicity Packet

In today's world, it is common (if not expected) that your press materials will be available in multiple formats at the time of the launch of your book: in print via traditional press releases, brochures, and postcards, as well as digitally via blogs, your own featured website, and PDFs sent via email.

Your initial efforts should be directed to those in the industry who already know you and your work, and only you will know that list (you should have already started a mailing list with their names). A general announcement should be more broadly circulated as your title's release date approaches, followed by more targeted promotion to specific audiences. It is wise to have different versions of your press materials: brief versions (140 characters for Twitter), medium length (blogs and websites), and longer narratives (for review consideration in traditional print publications).

The Internet

In addition to traditional marketing through print media, the current proliferation of personal and professional websites, blogs, social-networking tools, and other Internet resources are extremely valuable marketing platforms. The Internet contains an endless number of resources with which to publicize your book. Make it your goal to have your title and its content in front of people in a variety of formats and community spaces—in short, wherever people are looking, learning and communicating. Establishing a dedicated website just for your book project and creating a slide show or video piece for YouTube.com or Vimeo.com are two important angles to utilize. As you get close to the launch of your title, be sure you have

promotional packet by Lauren Henkin for *Displaced: Part I & II* includes CD, booklet and cards in a handmade tri-folio

secured the corresponding website addresses (URLs) and titles for your book's blog and social-media sites.

Much like POD technology, there are a number of affordable template-website-building services that offer an alternative to the professionally designed website. Costs are substantially lower than hiring a web designer and web programmer, and you can self-administrate the site, which further reduces costs. Templates are typically more simple productions, ones in which you determine the type of font and color scheme, language (i.e., "Portfolios," "Series," "Recent Work"), and more, and allow you to be in control of your website and to update whenever you want (with each upcoming book signing or exhibition, for example). Some allow the inclusion of a short QuickTime movie or a short slide show that you can narrate to serve as an introduction to the book.

When working with a designer on the design and implementation of your website, the image of your book's cover should be replicated effectively and prominently on the site—the potential book buyer needs to be able to easily identify your book in a crowded bookstore. Furthermore, the site can be designed so that the page layouts for the website can easily be printed for use as promotional pieces—no need for costly redesigns to create related marketing tools.

If you're not yet certain which way to go, or if you can only afford to launch a basic website at the time of publication, be sure to plan your website design so it can be easily expanded later. Website design and functionality is not the place to cut financial corners.

promotional packets by Mike Sinclair (for *Main Street*)
and Susan kae Grant (for *Night Journey* and *Shadow Portraits*)

Additional Activities

As you strategize about how to best market your book, identify ahead of time those key experiences or events surrounding the making and marketing of your title that could provide you with content for non-print formats for publicity. Creating a video about the making of your book that chronicles your path to publication can be a compelling and informative piece that could assist sales. You can also ask a colleague to conduct a casual interview with you about your publication project, or you could make a short film that guides viewers on a walk-through of an exhibition of the work. These ideas and others make for web content that will engage viewers across the spectrum. Keep your still and video cameras close at hand!

Exhibitions and Fine-art Prints

If the photographs featured in your book can be acquired as limited-edition prints, or are available to be presented as a collection in a traveling exhibition, it is wise to include that information in all formats of your press materials. In a perfect world, those who are introduced to your photographic work through the book will also be interested in your fine-art prints, and conversely, those who have already collected your photographs in a gallery setting will be interested in your book and this new body of work. In other words, this is a great chance to cross-market to all of your collectors and clients.

Organizing and circulating an exhibition of the images in your book will extend sales well beyond the launch of your title. Museum budgets are generally limited no matter what the economic climate; consequently, more venues are hosting traveling shows—rather than originating exhibitions—which can be arranged

We market all of our books the same way—by inclusion in our sales catalogue, working closely with independent booksellers and museum stores, and attending art and photography shows.

Chris Pichler publisher, Nazraeli Press

———

by the artist or by a third-party service. Typically, you can arrange a book signing for each function, and the host venue will carry your book in its gift shop. You can also partner with the institution to organize lectures and other programming that will draw the public in to engage with the work. Be mindful of planning ahead: exhibition venues on a local level may set their calendar six months out, while national venues plan much further in advance, sometimes three or four years into the future.

Just as when searching for the right publisher, it is important to match your subject matter to the appropriate venue. Art-museum exhibitions are highly pursued, but another type of venue might be a better match for your work. University art galleries, science-and-industry or natural-history museums, children's museums, historical societies, and even major airports host exhibitions. If your project has a special audience, then consider where that audience will be gathering—trade shows and annual conferences, for example. Nontraditional, temporary exhibitions can attract an entirely new audience. Be entrepreneurial when thinking about bringing your work to the broadest possible audience.

Local media (TV, radio, and print and online resources) may be interested in covering the exhibition and related events, making your book feel newly published all over again. These events will also generate new reviews and testimonials for you to post on your website. Be sure to document every event with images and video; photographs and video clips can go on your website and blog as well as in exhibition proposal packets targeting future venues for your show.

As a viewer, I want to be involved and challenged and left with a sense that a dialogue is ongoing even after I put the book down. Questions remain but I can trace them back to the book and continue to be engaged and surprised.

Raymond Meeks photographer and book artist

———

Local Opportunities

Promoting your book locally is another way to both cut early marketing costs and build momentum. Your local community will appreciate hearing about your project, and hearing it from you makes the experience even more memorable for all parties. There are likely many local venues to hold book signings and mount exhibitions—bookstores, libraries, community centers, educational institutions, convention centers, and airports are all possibilities with minimal, if any, lodging and transportation expenses. These are venues that your publisher and publicist will likely count on you to cover financially.

Beyond the Launch: Extending the Life of Your Book

When your book is out in the marketplace, keeping yourself, and your book, in the public eye is the business at hand. You have collected testimonials which are now featured on your updated website, and your PR pieces inform interested parties that you are available for interviews, speaking engagements, and exhibitions. The message you put out to the world during the post-publication process must be clearly presented to the person on the receiving end, no matter how much information you want to share. Your publication website should be current, with press and upcoming events updated and the website easy to navigate.

If you decide to send mailers to your target audience periodically over the life of the title or to coincide with an event, such as the launch of each related exhibition, make sure that you are thinking about the promotion of your book as that of a continuing consistently designed campaign during which you reference your website, discuss upcoming events, etc.

INDUSTRY VOICES

Jane Brown national accounts director, Distributed Art Publishers

My best piece of advice to those planning to produce a book of their photographs: Research! Research! Research! Spend lots of time at your local libraries and bookstores and get to know publishers through their titles and area of specialty. Cast your net wide when it comes to thinking about which publishers to collaborate with—book projects are really costly, and you want to explore all possible partners. Think about copublishing with a gallery, or museum, or other venues that will be showing your work. This will help offset the costs as well as the risks involved in producing your book by yourself.

A publisher and/or distributor is unlikely to bring in a book that is already published. Here's why: When you work with a publisher, you have the benefit of informed decisions about every aspect of production and marketing. When you go off on your own, the publisher has no say in the preparation and production of the book and is then being asked to take the book as is. In the latter case, the chances are one in a thousand that they will take it on.

The path of your book from the publisher to printer to the warehouse to bookstores and finally into the hands of the consumer all comes under the term "distribution." When the book hits the warehouse, the *selling* of the book begins. Sales representatives go to local stores, to wholesalers, and to online accounts with publishers catalogs in hand. The reps go through the list of titles and describe the relevance of each new book to each store's buying community. As a result of this conversation, the bookstore buyers place an initial order of books for their store.

Publishing your book is not over when the book contract is signed—it's just beginning. The most successful books I've seen over the years are books where the photographers themselves are out there marketing the work to a wide audience.

Lastly, be nice and considerate. It means a lot!

INDUSTRY VOICES

Shannon Wilkinson founder, Cultural Communications

When I first started Cultural Communications in 1996, our clients were publishers. We worked closely with the photographers during those projects, and as word spread, they began referring us to each other. Now almost exclusively authors and photographers hire us. Most use us as an adjunct to their publisher's in-house publicist, unless they are self-publishing. Our fees average between $7,500 and $10,000. We spend an average of five months on campaigns.

The biggest misconception that authors have about marketing for their book and working with a publicist is that if they hire the right person, "it" will all happen: that with a few phone calls to top magazine editors, feature stories will magically occur. This can actually happen if celebrities are involved, but rarely in other cases.

We generally advise authors and photographers that they should begin planning their publicity and marketing campaigns six months in advance of publication; if they want exhibitions at the time of the book's publication, they should start even earlier.

Websites and the Internet in general, are an extremely important part of any marketing campaign. A micro-site, which is a small website of perhaps four pages, is sufficient for a book website. One caveat: don't start a blog if you can't commit to contributing posts at least twice a week for a year. Social networking is also absolutely vital. We are doing blog campaigns for every title now. We also recommend YouTube videos and Twittering for most of our authors.

In addition to the word-of-mouth buzz that social networking provides, it is also increasingly important in light of the declining advertising revenue traditional media faces. That has resulted in fewer pages featuring profiles and reviews of books. We will see more publications continue to fold in the coming years, creating a more competitive atmosphere for obtaining mainstream book coverage.

Mark Laita, *Created Equal*
(Steidl, 2009)

In our experience, the most effective way to extend the life of your book is through a one- or two-year exhibition tour that is accompanied by public-speaking opportunities, such as author's talks and seminars that include a range of experts or peers who discuss the work or topic. These in turn help feed social networking, including author blogs and postings and links by other bloggers and audience members who might Tweet and otherwise share commentary about the experience.

POD technology, coupled with the promotional platforms that viral and social media provide, is transforming the industry. These changes have put considerable control in the hands of authors. If an author is willing to self-publish even a limited run of a new title and then promote it through a blog and viral media, she can attract an audience that she "owns." By that I mean that if she is able to attract a few thousand or more followers, she has a built-in market for her work and a better chance to attract the attention of a publisher. She can continue building her audience for years—or as long as she has sufficient content to do so, and if she chooses, bypass the publisher and sell directly to that audience. The added responsibility is that authors are now responsible for their own marketing and promotion.

The new economy is forcing publishers to publish less—and to demand more. They must feel confident that they can sell a book and minimally break even, and ideally make a profit. This situation will lead to even more self-published books in the coming decade.

INDUSTRY VOICES

Jo Whaley photographer

Years ago, a consultant gave me the idea to think broadly in terms of the exhibition and publicity opportunities that the subject matter of my photographs present. The work for *The Theater of Insects* (Chronicle Books, 2008) consists of lavishly constructed still lifes made of found and constructed elements from both urban and natural environments, and features rare and collected insects as the central motif. We know that the art world embraces all topics; it made sense that my work might possibly relate to a cultural or intellectual arena that lays outside the traditional boundaries of the art world.

My photographs are created as individual artworks, but they are often used to illustrate scientific journals and have appeal for entomologists. Exhibiting the work in science museums in addition to art museums was a logical step and has brought me into direct dialogue with scientists, which has in turn elevated the ideas that are the foundation of my work.

A major traveling exhibition of the work was launched by the National Academy of Sciences in 2008. The images are included in exhibitions that have roots in the scientific community, and that has helped to sell copies of the book to a lay audience. An additional benefit to collaborating with exhibition venues outside of the art world is that collectors who were unfamiliar with my work have begun purchasing prints.

Art and science are not diametrically opposed. The practice of both begins with an intense observation of nature, which sparks the imagination toward action. We just have to pause long enough to look.

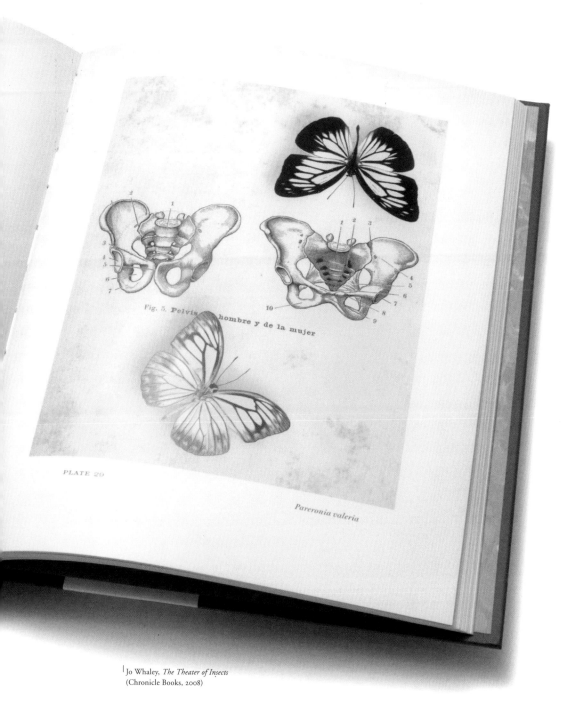

Fig. 5. Pelvis del hombre y de la mujer

PLATE 29

Pareronia valeria

Jo Whaley, *The Theater of Insects*
(Chronicle Books, 2008)

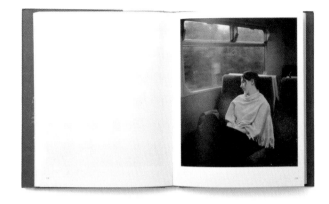

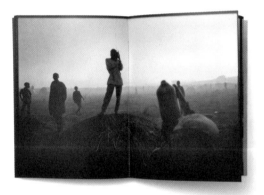

A selection of contemporary books that represents
the diversity of photobook publishing today:

Stephen Gill, *Studies* (Chris Boot Ltd., 2004)

Gerry Johansson, *Ulan Bator* (Gun Gallery, 2009)

Adam Fuss, *Mask* (Baldwin Gallery, 2005)

Fazal Sheikh, *A Camel for the Son* (Steidl, 2001)

Gilles Peress, *The Silence* (Scalo, 1995)

Bookselling in the Twenty-first Century

IT IS NOT NEWS TO STATE THAT BOOKSELLING IN THE EARLY TWENTY-FIRST CENTURY looks nothing like the last decades of the twentieth century. Ironically, over the past decade, while more and more photography books (and books of all types) were being published by a wide range of small and independent companies and an even wider range of first-time authors, the number of small and independent bookstores has diminished dramatically.

Bookstore closures have been fueled primarily by the boom in Internet business coupled with the retail price-slashing tactics of the Internet's number one bookstore, Amazon.com. Independent booksellers have had a hard time competing, but they are a driven group, seeking to keep an almost-extinct literary culture alive. Many of the most notable bookstores have emphasized and capitalized on their independent status and the specialization of their inventory in order to build and retain a loyal clientele.

Independent booksellers, like small independent presses, are willing to work very closely with photographers. Today, many photographers are producing small runs of books—from several dozen to one or two thousand copies—and then are selling them through their own websites and marketing the titles through their own blogs and Facebook and Twitter accounts. Reaching out directly to bookstores is key to selling books in the twenty-first century.

The publishing industry as a whole—from agents and authors to publishing houses and booksellers—has gone through, and continues to go through, major shifts resulting from, in no small part, the changes in the purchasing habits of the general public. Being versatile amid the flux is vital.

.

INDUSTRY VOICES

Rixon Reed owner and director, photo-eye Books and Gallery

When it comes to contemporary photobooks, what do you think are the most interesting things happening now? And by whom, in terms of artists and/or publishers?
RR: Small-edition book publishing opens up incredible possibilities that in turn allow for greater creativity and risk taking without the huge monetary burden found in traditional mainstream publishing. The technologies of printing and binding have advanced to the point where small print runs of less than two thousand copies are economically viable. It is now within the realm of possibility for many more publishers and artists to make unusual books and daring works, appreciated by much smaller markets. Nazraeli Press has been the stunning example of this for years, but there are many more throughout the world.

The handcrafted book is also important. This is becoming an exciting book form for more and more artists. While artist's books have been around for a long time, photographers are just now discovering the power of the handmade book. Take a look at Raymond Meeks's amazing books—*Sound of Summer Running* (2004) and *A Clearing* (2008), both by Nazraeli Press—as they are quiet, elegant works of art that command one's attention. It's truly an exciting time for the photography book lover.

What is your "philosophy" for bookselling? Why do you do it?
RR: I do it to provide important and wonderfully esoteric books, many not easily found elsewhere, to a focused and appreciative audience. Bookselling, as they say, is a labor of love, and it provides great riches in many ways. To me, however, it's the curatorial aspect of bookselling that is the most satisfying. Finding fantastic books, illuminating their importance, and sharing them with the right audience is quite delightful.

Raymond Meeks, *Sound of Summer Running*
(Nazraeli Press, 2005)

As an independent bookseller, how important to you is the Internet?

RR: Since photo-eye's home is in a small market (Santa Fe, New Mexico), there really is no other way for us to exist without an Internet presence. Before the Internet, we survived through our mail-order catalogs. Then in the mid-nineties, the Internet became an incredible game changer, and we were among its early adopters. In 1996 we launched our website, one of the first e-commerce bookstores, on the heels of Amazon.com. Soon, the breadth of material we could offer for sale online began to supplant the need for our mail-order catalogs. The Internet became our connection to the outside world, and we are constantly trying to expand that connection through the various evolutions of each of our online divisions.

What should photographers know and think about when it comes to creating a book and thinking about collectibility?

RR: I wouldn't focus too much energy on collectibility. It's hard to think about that aspect if a person isn't already well-known. There's a difference between someone doing a limited edition and marketing it to their immediate circle of supporters and someone's work being truly collectible. Film director and photographer Larry Clark was totally unknown when Lustrum Press published *Tulsa* (1971), but that book has truly become a collectible. I think Clark just had a burning desire to say something, and the book was the perfect medium for saying it. That said, I'd recommend that photographers think realistically about how big their market is before deciding on edition numbers or print runs for their books. Too many photographers have too many of their self-published books stored in boxes gathering dust in their garages.

Limited-edition and Collectible Photo Books

THE COLLECTIBILITY OF BOTH RARE AND IN-PRINT PHOTOGRAPHY BOOKS HAS also exploded in recent years. As discussed in the introduction, this is due in part to the academic attention to the history of photography books, the accessibility to a world-wide market via the Internet, the advancement of e-commerce, and the general fracturing of the publishing industry.

The collectible book market is as varied as any other collecting environment. Some people collect mass-produced trade books that are popular or have achieved some level of cultish status. Others are drawn to the handcrafted artist book and may either collect them for their own private collections or in support of a rare-book library.

When Andrew Roth's very personal survey of the seminal photography books of the twentieth century, *The Book of 101 Books,* appeared in 2000, buying and selling through the Internet on any recognizable scale was less than five years old. *The Book of 101 Books* became something of a shopping list for blue-chip collectors; and scouring the Internet for bargains, a full-time endeavor. The two-volume Parr and Badger book, *The Photobook,* was highly anticipated within the photography community, and appeared within a few years of Roth's book. But *The Photobook* introduced a more timely element—the book included a list of titles that were still officially in-print and readily available. By turning their attention to the trade editions of the moment, the authors encouraged photographers, dealers, and, most importantly, fledgling collectors to consider the output of today's artists and publishers as the collectible object of tomorrow. This was not a new concept—indeed, various industries, comic-book publishers and certain toy manufacturers, for example, treat their products as collectible from the outset, and first editions in

Without using words, Nathan Lyons' Notations in Passing (1974) persuaded me, through strong images and complex design, just how challenging and powerful every photograph can be or may become. I still learn from this one.

Roy Flukinger senior curator of photography & film, Harry Ransom Center

—————

literature have always been viewed in this light. But to the photography world, it was a novel concept that quickly took root and turned into a frenzy.

Originality and artistic vision remain key to a book's desirability, but relative fame of the artist, a book's scarcity, critical acclaim, and popularity, whether on a mainstream or a cult-status level, all factor in. Also of importance are the individual tastes of the collector. "I find it an amazing idea that a volume of photographs, even one from the distant past, can explode into life at any time," muses Parr in his preface to *The Photobook.* "As one turns pages," he goes on, "[those pages] can provide a flash of inspiration, changing the way in which both photographers and other readers think about the world."

Because of the sheer diversity of factors that constitute the collectibility of any given object, it is notoriously difficult to outline a formula for a book's success as a collectible piece. Trying to craft a trade book as a collectible object is especially difficult. But a high-end deluxe edition has a marketability of its own. The language of selling what is typically a handcrafted artist's book is different from the collectible trade edition, and many collectors and buyers will want to know very specific information about dimensions, the materials used, master collaborators, and other such technical details. Paying attention to the language you use to describe the book as a physical object worthy of collectibility, whether produced in a workshop or through a trade publisher, will indicate that you yourself consider the book as a collectible object to be considered on its own, in addition to its content.

SUGIMOTO
IN PRAISE OF SHADOWS

BAGHDAD
CALLING

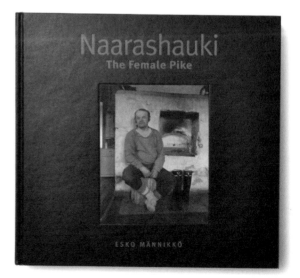

Martin Parr in INDIA
1984-2009

PHOTOINK

Naarashauki
The Female Pike

ESKO MÄNNIKKÖ

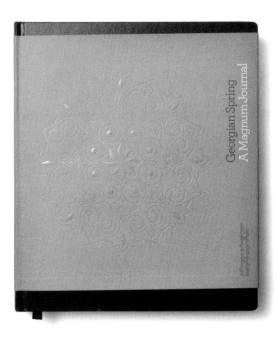

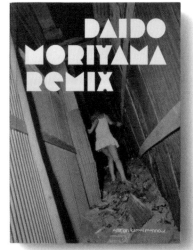

Selection of contemporary collectible photo books:

Michael Schmelling, *The Plan* (J&L Books, 2009)

Daido Moriyama, *Remix* (Edition Kamel Mennour, 2004)

Wendell Steavenson, *Georgian Spring, A Magnum Journal* (Chris Boot Ltd., 2009)

opposite page:

Hiroshi Sugimoto, *In Praise of Shadows* (Korinsha, 1999)

Geert Van Kesteren, *Baghdad Calling* (episode publishers, 2008)

Esko Männikkö, *Naarashauki, The Female Pike* (self-published, 2000)

Martin Parr, *Martin Parr in India 1984–2009* (Photoink, 2010)

INDUSTRY VOICES

Daile Kaplan vice president and director, Swann Galleries

Swann Galleries conducted the first auction dedicated to photographica and books, known as the Marshall Sale, in 1952. William Henry Fox Talbot's *The Pencil of Nature*, which sold for $200, was the top lot of the sale. By 1975 nineteenth-century photographically illustrated volumes valued at $100 or less were still staples of the market.

With the establishment and development of the fine-art photographic-print market in the 1980s, photobook sales expanded to include twentieth-century monographs. Berenice Abbott's *Changing New York* (E. P. Dutton & Company, 1939), sold for $175; Alvin Langdon Coburn's *London* (Duckworth and Co., 1909), sold for $1,500; Man Ray's *Photographies 1920–34* (Cahiers d'Art, 1934), sold for $450; Irving Penn's *Moment's Preserved* (Simon & Schuster, 1960), sold for $300; Edward Steichen's *The Photographer* (Harcourt, Brace and Company, 1929), sold for $225; and Edward Weston's *Fifty Photographs* (Duell Sloan & Pearce Publishers, 1947), sold for $150, were some of the titles that appeared regularly in our auctions.

What's interesting about the marketplace is how books reflect larger cultural trends. Certain titles speak to collective human concerns: Robert Frank's *The Americans* (Grove Press, Inc., 1959) crystallized a historic and transitional period in American social history; Henri Cartier-Bresson's *The Decisive Moment* (Editions Verve, 1952) fosters a sense of celebration and connection.

Though a book's content may stimulate interest, production values ensure longevity. Choices that an artist or a photographer makes with regard to photomechanical reproduction techniques, as well as sequencing, sizing, and formatting, are key elements in generating book lust in collectors. Unlike photographs, which are produced as either unique objects or created in very limited editions, trade volumes are created in large runs. The books that can garner the highest prices are those with their dust jackets

Robert Frank, *The Americans*
(Steidl, 2009)

in very good to excellent condition and with bright and tight binding. The other compo-
nent of a desirable book is its provenance or if it is an association copy—inscribed by
the photographer to someone of well-known stature. Knowing the lineage of a title is
important, but books that are inscribed and/or signed are particularly prized.

There are many contemporary artists and photographers who recognize the
book as a viable and distinct art form. Two titles that immediately come to mind as
exemplary objects are Paul Graham's *A-1—The Great North Road* (Grey Editions, 1983),
the deluxe edition, issued with an original photograph; and Hiroshi Sugimoto's *Theaters*
(Sonnabend Sundell Editions and Eyestorm, 2000). However, from my perspective,
what's a noteworthy issue isn't that contemporary photobooks are being published
more frequently; rather, it is that the photobook has become the subject of multidis-
ciplinary scholarship and connoisseurship. I hope to see a growing awareness of the
direct relationship between the artist's books made by figures like Ed Ruscha, Sol
Lewitt, and countless other artists and the photobooks crafted by photographers like
Alec Soth, Daido Moriyama, and Paul Fusco, to mention just a few.

PAULA MCCARTNEY

BIRD WATCHIN

Lisa M. Robinson Snowbound

VIOLET ISLE ALEX WEBB & REBECCA N

Alec Soth SLEEPING BY THE MISSISS

John Gossage THE POND

LIBRARY OF DUS

5

Case Studies

CASE STUDY 1: **ALEC SOTH**

Sleeping by the Mississippi and *The Last Days of W*

What started as a dummy book made from ink-jet prints, *Sleeping by the Mississippi* (Steidl, 2004), has become one of the most influential books of the last decade and is now in its third printing. Alec Soth continues to experiment with the book format, sharing his experiences with both trade publications and informal, self-published zines.

DH & MVS: Sleeping by the Mississippi *has become a legendary book in the photography community, is highly collectible, and has now entered into its third printing—yet it started off as a kind of artist's book. What made you decide to produce a small-run artist's book?*

AS: I did that body of work over the course of several years. I would take my vacation time and travel along the length of the Mississippi River taking pictures. I have always thought in book terms when it comes to my projects. This has to do somewhat with living in Minneapolis, the middle of the country, where access to photographic images comes primarily through books and not exhibitions. My biggest ambition as a photographer has been to produce books with my photographs, so I really thought of *Sleeping by the Mississippi* in terms of a book. I knew I couldn't really go to a publisher at that point in my career, so I decided just to make my own book.

When you made your maquette of Sleeping by the Mississippi, *did you produce the entire thing in your studio?*

I made ink-jet prints that were bound at a local bindery. Ink-jet technology had really just been introduced to the photography community, and it wasn't very refined. To be honest, I was reluctant about ink-jet prints in a fine-art context. A lot of my concern came from art-world snobbery. When you said the word "ink-jet,"

Sleeping by the Mississippi (artist's dummy)

you often heard the reply, "Anyone can make an ink-jet." So I had to get past that in my own head. The bindery cut me a deal if I did twenty-five copies. There wasn't any marketing ambition behind the number. The main thing was that I wanted to see this thing as a book. The ink-jets were a revelation compared to making a C-print and mounting it, which takes forever.

In 2003 you won the Santa Fe Prize for Photography for Sleeping by the Mississippi, *and part of the prize was a free spot at Review Santa Fe. Was that the first time that publishers (such as Nazraeli Press and Twin Palms) saw the book you had made?*

Yes, absolutely. Aperture was also one of them.

Yet Steidl, in Germany, ultimately published the book. How did you get in touch with Gerhard Steidl and decide to publish with him?

I called the photographer Joel Sternfeld at one point, and he talked to me about his great experience at Steidl. It seemed like it would be the right fit and the right thing for me to try to do. I also felt emboldened by the fact that I had other people interested in contributing to the book: I had sent curator Anne Wilkes Tucker at the Museum of Fine Arts, Houston, a copy, and it really spoke to her. She picked up the phone and told me that she would love to write for the book. It was so great to receive her call, and it was a perfect match.

What else was significant about creating those early copies?

The act of making the book itself, of sequencing it in a certain way, and going through the mechanics of putting it together was such a fabulous experience.

Though it is something that students now learn in book courses, it wasn't anything I had ever done. When you get a book back from a binder, there is a feeling that this is real, like you've really done something. It's the same feeling you get when you frame your work and hang it on a wall—it finally becomes something real.

What was it like working with Steidl?

Gerhard is a real collaborator, and he's able to grant great freedom to the artists he works with. The biggest evidence of our collaboration was for the first cover of *Sleeping by the Mississippi*, which is still my favorite of the three printings. Gerhard had this idea of printing an image right on the cloth of the book, which led me to think about isolating a part of one of the pictures. We used a photograph that shows stains on a wall. It's a very noncommercial cover, and it turned out to be really great. It could have backfired, with no one noticing the book because the cover image was so subtle.

With the second printing, Gerhard had the idea of printing the book as a paperback, which I liked, and of using a much more commercial and recognizable cover image. We decided to use the photograph of the man holding the model airplane in the snow, which had been used for the Whitney Biennial poster, on the cover of *Blind Spot* magazine, and some other places. But the book was accidentally bound as a hardcover. When that printing sold out, and we were discussing the third printing, we felt we couldn't simply go back to the first cover treatment as it had become very special and collectible by that point. So we chose a completely new cover image, and we'll probably just keep doing different covers in subsequent printings.

Sleeping by the Mississippi
(Steidl, 2004)

The Last Days of W |
(Little Brown Mushroom, 2008)

You recently self-published a one-time "newspaper" called The Last Days of W *under the imprint Little Brown Mushroom. What is Little Brown Mushroom?*

Little Brown Mushroom is my playground. I really like magazines, especially the more alternative ones, and I wanted to play around with a different type of book format. After the success of my blog and my decision to take a break from blogging for a while, I wanted to publish my own little zine. I was interested in tactility but just didn't have enough time to actually make it myself by hand. Suddenly this idea for *The Last Days of W* popped into my head.

At the time I was in Switzerland for a show of my work at the Haunch of Venison gallery, and I thought I'd self-publish the book and print it in Europe. I found a printer in Amsterdam and toyed with the idea of making it available only in Europe. But it was a numbers thing: if I printed ten thousand, the unit price would go down, even though I didn't want that many copies at first. So I decided to do ten thousand copies and shipped half of them to the United States. I quickly set up a little website and sold the books through it.

You've treated the captions in each of your books differently. Why?

With captions there is a struggle between how much information to give and how much to allow the pictures and the sequence to speak for themselves. At the back of *Sleeping by the Mississippi*, there are footnotes with thumbnails of the pictures. With *The Last Days of W*, I thought it would be funny to use the newspaper format but in an anti-newspaper way, with no traditional book cover at all. It's really minimal—you won't get ink on your fingers. There are simply the pictures with a lot of white space around them, which is kind of shocking

and unexpected in newsprint, somehow. I was playing with the traditional use of that format.

What do you think of print-on-demand technology?

Print-on-demand is very interesting to me. But you've got to pair the use of it with the right project. A problem I see with print-on-demand is that it can be too easy to reach a sense of accomplishment. It's so easy to make a book with that technology, but it doesn't guarantee that the work is any good. I'm sort of jealous at how easy it is, too! Where I think it gets especially interesting is for the future of an organization like Magnum Photos, which was originally founded during the heyday of *LIFE* magazine when so many news organizations were giving photographers fabulous assignments. Although most of those photographer-magazine relationships have gone away, today you have the opportunity to create your own magazine, be your own producer and your own publisher. It's a really exciting time.

CASE STUDY 2: **PAULA MCCARTNEY**

———

Bird Watching

Paula McCartney's love of handmade artist's books has long been part of her artistic practice. She shares with us how her limited-edition volume, *Bird Watching* (Princeton Architectural Press, 2010), caught the attention of Princeton Architectural Press and describes the path it took from artist's book to trade publication.

DH & MVS: *You recently published a trade edition of* Bird Watching *that is based on your handmade artist's books. How do those artist's books fit into your overall artistic output?*

PM: I first experimented with making artist's books after taking a weekend workshop with Susan kae Grant in 1996 at the International Center of Photography (New York City) when I was a student in their photography program. I made a unique artist's book for my student exhibition that spring.

I made a few more unique books after that, but books didn't become a part of my artistic practice until I took a semester-long course at the San Francisco Art Institute as a graduate student in 2001 with Charles Hobson. I was making mural color photographs at the time and printing them myself. My arms were just barely long enough to handle the paper while printing—it was quite an unwieldy process. When the prints were on the wall, the viewer had to stand back a bit to take in the image all at once.

It was during this time that I became really interested in the medium. I was attracted to making books because of their intimacy, which was a direct contrast to the mural prints. A viewer could hold the books in their hands and read through them page by page in a predetermined sequence and at their own pace. I was excited by the fact that I could break apart the larger mural prints I was making—I

Bird Watching
(Princeton Architectural Press, 2010)

was literally cutting them up—and guide the viewer piece by piece through my landscapes, effectively creating new landscapes on each spread. For my final project, I made an artist's book in an edition of five, which is now in the book collections of Stanford University, the Museum of Modern Art, and in several private collections.

Bird Watching *is now your seventh artist's book. Since that first graduate-school project, how have books figured in the expression of your ideas?*

Since that book I have been making photo-based artist's books that explore the intersection of art and science and the idea of constructed landscapes through both the collection and creation of natural elements. I want the viewer to consider a landscape and the world that exists within that landscape and the ways that the world can be elaborated upon. Books are interesting to me because they provide an accessible, personal, and intimate experience for the viewer. They can also be a self-contained exhibition, viewed and experienced repeatedly without the limitation of schedule or access to the location of a physical exhibition.

It is very important to me that my books are artworks in themselves, not merely portfolios of my photographic projects. In fact, in all of my artist's books, except for *Bird Watching* and *Accumulations* (2002)—which I made prints of only after I received so many compliments of the work—the photographs were made only for the books—they do not exist as individual prints. Many of the photographs that appear in *Bird Watching* have been cropped, and only about half are available as prints.

Most photographers seem to simply showcase their work—sometimes quite beautifully—in a hand-bound case or in a print-on-demand book and call that

an artist's book, which I think is a very loose use of the term. I think of books as a medium—like painting, photography, or sculpture—where all of the elements, including form, content, and materials, are in dialogue with each other and are meaningful to the finished work. This is what I think distinguishes my books—the photographs are only a part, albeit an important one, of the content. Without the concept, text, design, and materials, the books would have a different meaning.

How did Princeton Architectural Press come to be the publisher of the trade edition of Bird Watching?

In May of 2006 I went to Review Santa Fe and met with Editorial Director Jennifer Thompson of Princeton Architectural Press. I showed Jennifer my artist's book, and to my excitement she asked me to send it to her with some ideas of how the thirty-page artist's book that contains twelve photographs could be expanded into a trade edition. I spent the summer expanding the book, first by making a ten-page mock-up to show the editors at Princeton Architectural Press how it could be expanded. After that first editorial meeting, I began working with Senior Editor Nicola Bednarek Brower, who informed me that they were interested but still couldn't imagine it as a full-length book of roughly one hundred twenty pages.

So I took a few more months that fall and created an entire finished text block incorporating the thirty-four photographs that now make up the series, along with field notes, diagrams, and specimens sequenced and laid out according to my vision. It was this version that the press decided to make into a book. In retrospect, I should have made the full layout the first time—I realized that they couldn't envision the final product as I saw it in my mind. Once I had created the full mock-up,

Bird Watching

they no longer had to imagine how it would work out. It was right there in front of them. I would guess that things are a bit different with a traditional monograph, where the designers would have more say about the layout and design of the book, but mine was very conceptual from the beginning.

How did you find the process of creating the trade edition?

At first I thought it would be difficult to spend several months of studio time remaking a piece that I had already made several years ago, but I ended up really enjoying the process. At the point in time when I made the artist's book, I was in the middle of the project and had only completed half of the images in the series. There were also a few things I wish I had done differently in relation to the writings and illustrations. Making the text-block mock-up for the trade edition for Princeton Architectural Press allowed me to revisit the book and include the new photographs as well as rework and expand the writings. I was also able to change one thing in the "parts of a passerine" illustration—instead of labeling the birds feet correctly as tarsus, I labeled them as wire to clue the viewer to the fact that the birds are fake. It is something that probably no one will notice but totally cracks me up.

Of course there was another incentive to make this new version of the book: a much wider audience would be exposed to my work through the trade edition. While my artist's books have made their way to both private collections and public institutions with some degree of success, relatively few people have ever seen the actual books. Even when they are exhibited, the viewer usually gets to see only one spread of the opened book. The trade book will be affordable and accessible to a much wider audience, and that's something I am very excited about.

On the one hand you are probably very excited to have your first trade-published monograph, but on the other hand, were you a bit apprehensive in turning your artist's book into a more commercial object?

Overall, the process has been an extremely positive one. It has definitely been a learning experience that I feel I will benefit from well into the future. The most difficult part was giving up what I felt was 100 percent control over my work. Since the book as a whole was already executed as an original idea, and because Princeton Architectural Press wanted to publish it based on that idea, the design of the trade book has stayed very true to that original idea. Nicola has been very supportive of making sure that I am happy with any changes that Deb Wood, the design director, and Bree Apperley, the designer, have suggested and has let me make the final call—something that I am very thankful for.

The benefits of working with an editor and designer is that they were able to offer a fresh perspective on the work, and they came up with a cover for the book that is completely new and differentiates the trade book from the artist's book. In the end, because I had made the full mock-up and it was that mock-up that got the press really excited, I never really did give up all of the control.

Were there any other challenges?

Another challenge for me was patience. It took about a year from meeting Jennifer in Santa Fe to receiving a contract for the book. The difficulties of turning the artist's book into a trade book took more time than I ever imagined. Then there was the fact that I'm in Minneapolis and the publisher is in New York City. At the

Bird Watching
(limited-edition artist book)

beginning it was difficult to communicate ideas over the phone as precisely as I could have if I was there.

As I'm writing this, I have just received the unbound printed press pages of the book, and they are sitting on my desk. Seeing this new version of the book become a reality has been equally as exciting as when I bound the first in the edition of artist's books. An aspect of this process that was very helpful was talking to other artists that have had books published, getting the advice of Debra Klomp Ching and Darren Ching from the gallery KlompChing (New York City), and talking to other supporters of my work in the field. I'd say, take advantage of your contacts for advice during this process.

CASE STUDY 3: **DAVID MAISEL**

Library of Dust

Library of Dust (Chronicle Books, 2008) is atypical in many ways: a morbid subject afforded a lavish, oversized production by a major trade publisher. David Maisel speaks to us about the publishing process that memorialized the lives of his subjects through gorgeous photographs and provocative essays.

DH & MVS: *How did the provocative title,* Library of Dust, *for this newest body of work come about?*

DM: The subjects of the book, for the most part, are copper canisters from the Oregon State Hospital, which is a psychiatric hospital. The canisters are filled with the cremated remains of patients from the hospital and were unclaimed by their families. Over time, the human ash within started to react with the copper urns, and each one has become this kind of exceptional, singular object encrusted with minerals on the surface.

I went to the hospital for the first time a few years ago with the superintendent. The hospital had been active until the 1970s, but two-thirds of it had been closed for forty years. In fact, *One Flew Over the Cuckoo's Nest* was filmed there soon after it closed. So the hospital has this very strange kind of medical-fiction aspect to it and a very strange backstory.

Exploring the hospital was a whole process of methodically unlocking the doors of the various buildings. I found myself in an incredible room that was charged with the presence of these canisters, these objects. They were more stunning than anything I could have imagined.

The idea of the title actually began within fifteen minutes of walking into this room. As I was setting up to photograph, some convicts from the state penitentiary

Library of Dust
(Chronicle Books, 2008)

were across the way cleaning hallways. I looked up, and there was an eighteen-year-old in a blue jumpsuit standing in the doorway. He looked around the room, scanned the canisters on the shelves, and whispered, "Oh, the library of dust." Instantly, he had given the project its title and had inadvertently given the project a thematic structure—that, actually, the room itself was a library.

This structure has been carried throughout the book quite well. Was this something that happened during the editing or were you working all along with this internal structure?

I knew it had to be a book right from start, but I wasn't really thinking about the form of the book until I was almost done. I don't know if I'll ever be done making pictures there, at the hospital. So, I wasn't really thinking about it as I was making it.

Did the final book end up looking like the maquette you made?

Hardly at all. My maquette was about four or five inches thick and weighed about eight pounds. It was not nearly as large as the final book that Chronicle published, in terms of length and width, but it was much thicker. In making the trade edition, we actually experimented with thickness and wondered whether we should print it on boards. We also made a book dummy that had French-folds. We had a nice amount of time to work on the book and to play around.

Tell us about the process of going from idea to tangible, printed object and what it was like working with your editor at Chronicle Books.

We decided we would take our time. A few things happened along the way, and we started working on the book before we had a contract. There was a level of

trust between my editor, Alan Rapp, and I that was really reassuring. I had put out queries to contributors who I thought would be a perfect match for the book. I also started working with Bob Aufuldish, the designer I've been working with on and off for fifteen years, on sequencing and things like that. Alan had actually taken the book on mostly because of a book dummy that I'd made. He saw the maquette and said, "I have to present this to my editorial board. Will you let me present it?" He really shepherded it through that process.

Chronicle was amazing to work with. I think they basically let all of their internal rules be broken in terms of its scale and the ambitious nature of it as an object for the trade-book market, along with the amount of time we took with it.

What were some of the organizational constraints you felt preexisted in the subject?

Something that I knew from the start was that the canisters had to be reproduced in the book according to their numbering system. That was, to me, a given within the context of the title and the metaphor of the space as a library. I wanted there to be a way to somehow express that what you were seeing in the book was just a mere fragment of the canisters in this room. On the front set of endpapers, we list the numbers of the canisters represented by a photograph in the book, and in the back are all 5,100 numbers representing each canister in the library. This acted as a generating device for how we treated type throughout the book.

The essays are also tied into different images within the book. Terry Toedtemeier's essay talks about how the mineral deposits and stains on the canisters actually formed, and we used close-up images of one-inch fragments of the minerals to illustrate his piece. For Michael Roth's essay, objects that I found in some of the

abandoned wards—handmade newspaper cutouts—served as ready-made art pieces that accompanied his text. Both essays brought another layer to the book: they became a prismatic or cumulative depiction of the hospital.

The few images of the hospital and the abandoned wards grounded the photographs of the canisters, in a way, and made the book richer. My initial impulse was to not show any of the surroundings at all, but I realized that viewers who didn't have any knowledge of my photographs of canisters needed those images to give them a sense of what they were looking at.

It sounds like you took loads of really interesting photographs of the hospital, but at the same time you ended up setting aside much of that work to focus on the canisters and the notion of the library. Is that right?

That's a good point. I actually felt that the material warranted a tight focus. This place is an unforgiving, unremitting kind of environment, and it seems to raise all sorts of existential questions and issues. I had to be strict, and in a sense, it was really much easier to be strict with myself and with the design. I came up with a set of rules, and once they were imposed, there was no deviating from them. I turned the idea of a library over again and again in my mind, and that's what locked me into this whole sense of how the numbers would work or not work.

I've made photographs of over one hundred of the canisters, and I knew the book would not support all of those images. There has to be a point in the book where there is a break and something else emerges. My methodology, of creating a dummy and pinning photographs up on the wall, is totally basic, but it really helps me to make this thing physical, even if on a miniature scale.

How did you come to the final sequence in the book?

I knew I wanted to start with an image of the room, and I had already decided on which photograph. I also knew that I wanted to end with the state that the canisters are in now, which is the last image you see. So after that, there was the question of pacing and knowing that I couldn't include every single photograph I had made of a canister. There are colors and forms that repeat, but I wanted to be able to show some of the canisters with evidence of the paper labels that remain on a few of them. I thought that was really important. I also wanted to be able to show the numbering system on the lids. As the project developed, some of these stipulations came into play after I had already been making the photographs. So it all developed over time.

When you describe making the maquette, you're describing something that is completely manual. You make a pile of paper prints, stacking them and turning it all into a book. What are your thoughts about the book as an object, as a material thing?

My desire with these books is to give a rich experience to the audience. Ultimately, I hope the project gets to live on in people's libraries. There have also been interesting things percolating ever since the book was released. Relatives of patients in the hospital have started to reclaim the canisters of their loved ones. The hospital encourages that, so there's been a sweet aftereffect that will probably continue. I received an email recently from the descendants of a woman who had been a patient at the hospital, and it was the most poetic letter. This kind of unpredictable effect due to the work moving out into the world is due not to any exhibitions but ultimately to the book form.

Library of Dust
(artist's dummy)

CASE STUDY 4: LISA M. ROBINSON

Snowbound

In addition to securing exhibition venues for her photographs, Lisa M. Robinson was certain she wanted *Snowbound* (Kehrer Verlag, 2007) to exist as a beautiful book. Utilizing POD technology to explore editing and sequencing at periodic stages, she eventually used these early versions to find a trade publisher for her work.

DH & MVS: *Tell us about the role and importance that conceptualizing your work in book form factors into thinking about your photographic process.*

LR: Making a book is a way for me to organize and sequence a project that I'm working on. I think of the book dummies as sketches rather than definitive, completed projects. The process itself is a creative one, which helped me determine what I was trying to do with the *Snowbound* images as I was making them.

One of the first realizations I had about the power of the book format came as I listened to the dialogue between my images when they were placed side by side. While I enjoyed the ways in which the images expanded in reference to one another, I was simultaneously aware of how such relationships reduced the power of each individual image to speak its own language and reveal itself fully, however subtly. I couldn't help but think about how I wanted these images to be experienced, to evoke the sensations I had when making them—alone, in a deep, internal space that was rooted in the physicality of the land and the snow. It seemed to me that as I juxtaposed images, I was shutting down some of that expansive space for the images and the internal, meditative space for the viewer.

So I placed just one image on one side of a page with the title on the facing page. I was making these dummies for myself, as part of my creative process, but very much with the hope of one day showing it to somebody and developing it into

Snowbound
(artist's dummies and trade book)

a trade publication. The last handmade dummy book that I made was the one that I eventually submitted to Kehrer Verlag, who later published the work.

How did this dummy reach the right people at Kehrer Verlag?

There is a quote by Vincent van Gogh that I've always had in the back of my head: "Great things are not done by impulse but by a series of small things brought together."

I received a Light Work artist residency in Syracuse, New York, in 2006. That residency enabled me not only to make new images but also to prepare the digital files that would later be used for my book. I attended portfolio-review events and was invited to exhibit the *Snowbound* work in various festivals. In 2006 I exhibited *Snowbound* in seven different countries. Basically, my rule of thumb was to say yes to everything and figure out the logistics later, and that has pretty much been my rule to success. When you have a lot of different things going on, ultimately bigger things will come your way.

Throughout this, I continued to stay in touch with the people whom I had met at the various review events. One such person was Celina Lunsford, the director of Fotograf Forum International in Frankfurt, Germany, who then recommended my work to Alexa Becker, the editor at Kehrer Verlag.

I had been working on this series for four winters when Alexa contacted me via email. By then I had worked through many of the creative issues surrounding *Snowbound* as a book project, such as the editing and sequencing. After an email correspondence in June of 2006, I sent a CD, a dummy book, and support materials to Alexa in Germany, and we arranged a meeting for the fall.

When did you first meet the people at Kehrer?

Our first personal encounter was September of 2006. I met Alexa Becker and Klaus Kehrer, the founder and publisher of Kehrer Verlag, in the Kehrer studio, which is housed in an old porcelain factory. The space is inspiring in many ways, and the layout of the studio actually speaks a lot about the collaborative process that characterizes the publisher. The collaboration that has occurred between myself and Alexa and Petra Wagner, the designer with whom I worked, is something that happens on a daily basis within the family of Kehrer.

Since I had sent my dummy book earlier, that first encounter was an opportunity to meet in person and discuss the possibility of a real publishing relationship. Talking to Alexa afterward, I realized how important personal rapport was, because you work very closely with each other. Just to give you an idea of chronology, I finished the project at the end of February 2007, and approached writers for the introductory text in March 2007. The plan was to have the book ready for fall, so I would have to be on press by the end of August. I completed my digital files and guide prints by June 2007 and sent them to Kehrer. They had the sequencing, the digital files, and the guide prints by July of 2007.

Tell us about the limited-edition version you produced.

Kehrer gave me a number of the unbound printed book blocks—the unbound but printed pages from the interior of the trade edition. We had agreed that Kehrer wouldn't produce a limited edition, but that I would do something on my own. I was fortunate enough to be referred to Jace Graf of Cloverleaf Press, a book artist in Texas, and I collaborated with him on the limited edition.

Snowbound
(Kehrer Verlag, 2007)

The limited edition of *Snowbound* is a handbound book with a tipped-in color photograph on a white linen cover. The images from this series are very much about a meditative, internal space in an open landscape. Although I'm photographing in the middle of winter, signs of spring and summer are omnipresent. The white linen is a cloth that could embody such complexities: it suggests both summer (as a lightweight fabric) and winter (the color of snow).

So there were a lot of ideas at play. Jace was probably ready to kill me by the end of the process. Sometimes I would wake up in the morning with this brilliant concept and send something to him. We talked endlessly—constructing, choosing fabrics, and making small decisions along the way. It was made in an edition of seventy-five. It comes in a beautiful clamshell box with a pale blue ultra suede pillow on the inside and one of three 8 x 10 C-prints. Each print is made in an edition of twenty-five. You select which one you would like, and it's placed in an exquisite letterpress folio.

How did you market and promote the book?

I have been rather tireless since the official book launch, lecturing and exhibiting as much as possible. I act as my own agent—I wish that I had an agent! I would love to believe that it's my publisher's responsibility to be my agent, but I know that they're working as hard as they can to make books and I'm working as hard as I can to make photographs. I realized that in order for the work to have an audience, I simply needed to show it to people. When the book arrived in November, 2007, I committed myself to six months of promoting *Snowbound* because it's a project that I really believe in.

Looking back on the experience, is there something you would share with those beginning the journey of publishing their first book?

It might have helped to know that it would be a 24-7 job that has little to do with the creative joy of making images. It's a creative process unto itself, as well as an administrative one. It was wonderful to be engaged with so many people at such different levels who love the work and who love the book. Had I known how much energy it was going to require and how much frustration I was going to experience, how many efforts I would make that would result in nothing, I would have been dismayed. So, if anything, it would have been valuable for me to hear from some-one who had been through it to tell me to be persistent and to have faith. To have faith that my intentions and efforts were cumulative steps toward something larger. When that kind of focused belief and commitment infuse the work that one does, it becomes apparent to others, who will then also believe in it.

Book publishing is definitely a job of passion in many ways—passion for the photographer as well as the publisher. We are all committed to making something larger than ourselves, something that will take on a life of its own. There is value in that kind of integrity. And the reward may not be an immediate financial one for either the photographer or the publishing house, but it is fulfilling in many other ways. The power of the photograph continues to amaze me. The power of the book is beyond my full comprehension.

CASE STUDY 5: **ALEX WEBB AND REBECCA NORRIS WEBB**

Violet Isle

Violet Isle (Radius Books, 2009) is the first publication featuring photographs by both Alex Webb and Rebecca Norris Webb, two accomplished photographers. Together, they present a unified and exciting artistic vision. They share how collaborating on their first book helped them become better collaborators overall.

DH & MVS: *There are not many books published by two working photographers. How did this project evolve?*

AW: This book began as two separate projects: my exploration of the streets of Cuba and Rebecca's surprising discovery of unique and sometimes mysterious collections of animals throughout the island—from tiny zoos and pigeon societies to hand-painted natural-history displays and quirky personal menageries. As we photographed more extensively in Cuba, however, we began to realize that despite the differences in our ways of seeing and our choices of subjects, our work sprang from a response to a similar notion: the atmosphere of a nation in a kind of bubble—an economic, political, cultural, and ecological bubble, the latter of which scientists now say may protect Cuba environmentally because of the dearth of plastics and other pollutants.

Before our last trip to Cuba, we showed our photographs to a book editor, and former collaborator, who suggested weaving our two bodies of work together. Initially, we were somewhat taken aback. Even though we'd helped the other edit books before—*Crossings* (Monacelli Press, 2003) and *Istanbul: City of a Hundred Names* (Aperture, 2007) by me and *The Glass Between Us* (Channel Photographics, 2006) by Rebecca—we'd never attempted to edit a joint book of our photographs. Not knowing where to start, we asked another friend, who is very familiar with

Violet Isle
(Radius Books, 2009)

photography books, if there was any precedent of two photographers with distinct styles interweaving their work. Only a few such collaborations sprang to mind for him, including Martin Parr and John Gossage's joint book, *Ordinary and Obvious* (Rocket Gallery, 2007). So we were wandering into virtually uncharted territory, a prospect that was initially daunting but ultimately exciting.

RNW: In fact, we realized later that *Violet Isle* was probably the most dynamic and challenging and surprising book sequence we've ever attempted. In the process, we discovered that by interweaving our Cuba photographs—with their echoes and tensions and cracks and contradictions—we were able to create a more unique and complex portrait of the "violet isle," a place prone to both political and romantic clichés, than either of our bodies of work could have done independently. That's what we found so fascinating and mysterious and humbling about collaborating on this project. "Cracks are a given between one collaborator and another," the poet C. D. Wright once wrote (in an interview in *Jacket* magazine, December 2001) about her collaboration with the photographer Deborah Luster. "That's how the light gets in."

Ultimately, *Violet Isle* explores not just the streets of this Caribbean island but also the relationship between Cubans and the natural world. This collaboration allowed us to embrace visually and conceptually the enigma of Cuba, what Pico Iyer, in his essay in the book, calls the "ambiguous island."

AW: What Rebecca and I also discovered through collaborating on our first book together was that the spirit of collaboration permeated the whole project. David

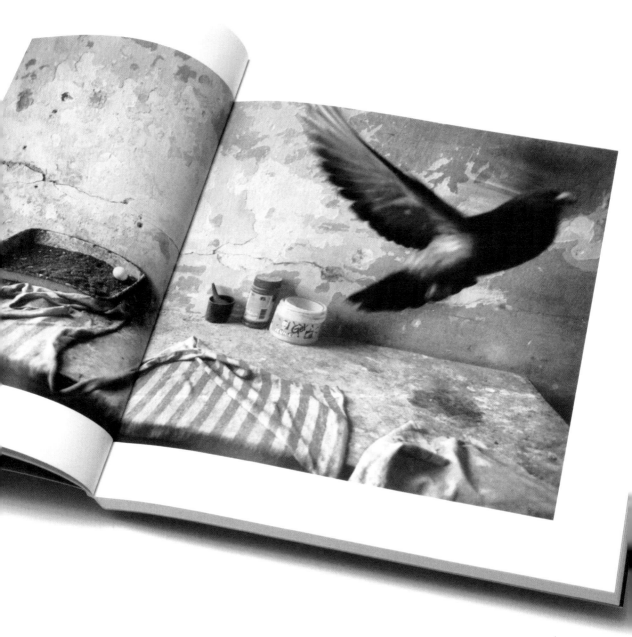

Chickey, publisher of Radius Books, created a design concept that references the Cuban tradition of handmade books, and Esteban Mauchi, our photographic printer, created a seamless and cohesive set of match prints that guided the reproduction process. His prints were used very successfully by the Singapore printing team. And finally, the spirit of collaboration was evident in our exhibition at Ricco Maresca Gallery in New York City, which was superbly and insightfully curated by Frank Maresca, echoing the musicality of the book.

Because this project was so collaborative, how did you work out the editing and sequencing issues along the way?

RNW: When making a book, we both like to live with the images for a while. We tack or tape little prints on the wall of our studio, and slowly, over time, rework the sequence. Shortly thereafter, we start building a book dummy. We especially like the tactile process of physically working with the images. For *Violet Isle*, for instance, we made cheap color copies and taped them into a blank sketchbook roughly the size of the book we envisioned.

Somehow, the time it takes to move pictures around in the book dummy—taping some images in and removing others—seems to suit the pace of our bookmaking process, which is primarily an intuitive and emotional process, better than simply designing the pages with some sort of computer software.

What was the process of being on press in Singapore like?

AW: Being on press is one of the most excruciating and exciting experiences for a photographer. Unlike making a print, where one can leisurely rework the

image, one is always under time pressure when on press. Here's basically how it works: The pressmen set the plates and get the rotary press running. Once it's warmed up, they pull off a single sheet that contains several printed pages, called a signature, and ask you what color corrections need to be made. And once you decide, there's no going back. Moreover, the more time you spend deciding and the more corrections you make, the more anxious the press people become. Time is money for them. The pressure can feel a bit like an athletic event.

The reality of offset printing can often be disconcerting to photographers. For one thing, something is inevitably lost in the translation of going from a continuous-tone photographic print to the screened dot system used for a printed book. Most frustrating of all, however, is that books are printed in signatures—so having to color correct one image can deleteriously affect another image printed on the same sheet of paper. On press, one is often plagued with a dilemma: Which image is more important? Which one can be sacrificed?

For *Violet Isle*, what was particularly problematic was that 75 percent of the photographs were split across double-page spreads, and sometimes the two halves were on different signatures, which meant that, at times, adjusting color got tricky. But it is the nature of the process, and we're very proud of the end result.

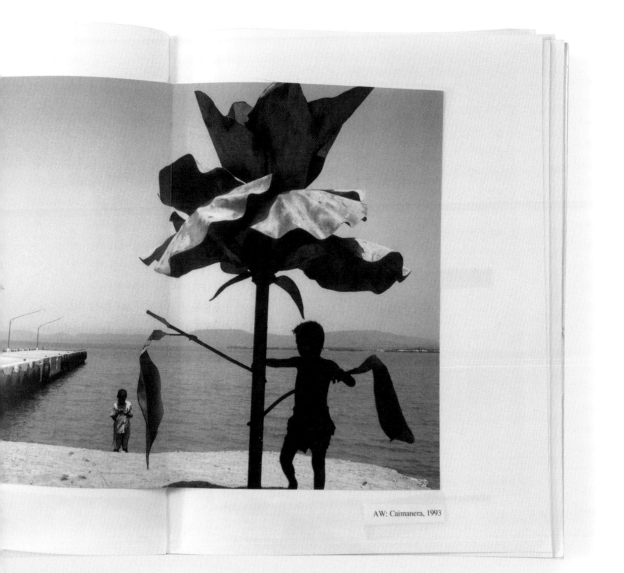

AW: Caimanera, 1993

Violet Isle
(artists' dummy)

CASE STUDY 6: **SEAN PERRY**

Transitory and *Fairgrounds*

It was Sean Perry's love of the photographic book that motivated him to create *Transitory* (Cloverleaf Press, 2006), his first publication, a limited-edition "plate book" with just twenty images. Many of the labor-intensive hand-crafted elements surfaced again in his second title, *Fairgrounds* (Cloverleaf Press, 2008), a book that combines commercial printing and handbound touches.

DH & MVS: *Why did you decide to produce a book with this small group of photographs?*
SP: My mom was a librarian, so my introduction to photography was at the library. I've had mentors, but my inspiration comes first and foremost from photobooks. To make something like the monographs I greatly admire by photographers, such as Tom Baril or Irving Penn, was a marker for me to work creatively toward.

Can you tell us about the photographs in Transitory?
The body of work consists of architecture visualized in three segments: abstract, electrical, and concrete studies. The work is about the presence of familiar structures versus the environment they occupy.

Describe for us the structure of the book.
I decided to produce this as a "plate book" in which handmade prints are tipped onto the pages. I have always liked the structure and atmosphere of tipped-in prints. The book is not oversized—it's only 9 x 8 inches—which brings an air of intimacy that I am drawn to. There are thirty pages, with ten carbon-pigment prints and one laid-in platinum/palladium print measuring 6 x 6 inches. The introduction by Roy Flukinger, the senior curator of photography and film at the Harry

Transitory
(Cloverleaf Press, 2006)

Ransom Humanities Research Center in Austin, Texas, and all other text are let-
terpress printed. The custom case is covered in silk with title blind-stamped details.
The edition is eighty-even; the price began at $450 and has since gone up to $550
after one-third of the books were sold.

Had you defined an audience for this plate book before you started production?

The people that have seen my work in galleries were the initial base. Then,
because of the attention to design and craft and the content of the imagery, it has,
surprisingly, really appealed to architects and those interested in design. There are
little, minute details about the book that people who appreciate design love: the
way that the pages and papers are scored and how the very last page of the book
holds the watermark of the paper that we used, for instance.

Who was your collaborator on the book?

Jace Graf, of Cloverleaf Press in Austin, Texas. He is a book artist and
deserves the bulk of the credit for the craft and design details. Jace is an inspiring
collaborator, and he is as excited about what he does as I am about what I do.

*How has the book complemented your gallery relationships and your print sales? Did
Stephen Clark (Stephen Clark Gallery), your dealer in Austin, feel like you were compet-
ing with his efforts to sell your prints?*

While books have their own collecting audience, the book has supported
print sales, without question. At the 2008 AIPAD (Association of International
Photography Art Dealers) show in New York City, we displayed the book, a large

photograph from a new body of work about architecture, platinum prints from the *Gotham* series, as well as silver prints from the *Transitory* series. Many people that bought the book have investigated my work further by purchasing prints through the gallery and/or visiting my website (www.seanperry.com). Some collectors have specifically wanted to buy prints that are featured in the book.

How has the website created new audiences for your book?

I purchased the URL www.transitorybook.com to allow for coverage of the three books in this trilogy, and it is linked to and from my main website. There is the obvious value in linking off of one's primary website, but it also serves as its own destination, without people having to already know my name. The book website is a collection and destination for all things surrounding this extended project, including exhibition information and radio interviews. The website has become the press kit for the book as well as a place to put testimonials, pictures of the book, and production and purchase details.

Did you find that marketing this book required a different vocabulary from marketing and promoting fine-art prints?

Definitely. You can't expect others to do your marketing for you—you have to be able to talk about and introduce your work yourself, and to learn the business of each specific marketplace, be it the publishing or print arena. I've enjoyed learning to conduct business in both. For me it has been important to learn the language so that I have something to contribute—I want to be a participant, not just a recipient. The entire process has been so rewarding.

Let's discuss your latest book, Fairgrounds, *which is also self-published.*

 Stephen Clark Gallery presented a solo exhibition of *Fairgrounds* in the fall of 2008, the first showing of large-scale prints from the series. I wanted to produce something special alongside the show, and again asked Jace to accomplish a near impossible task: produce a beautiful hand-finished object that could be sold at an aggressively inexpensive price point. My intention was to make something exquisite yet affordable and offer it as a small thank you to my audience of collectors. I plan on pursuing and publishing this series as a trade edition and thought this to be a unique opportunity to introduce and move the project forward. It was published as a Cloverleaf Press title in a limited-edition printing of five hundred copies, each signed and hand numbered. It was sold through the gallery and a few select bookstores for a retail price of $25.

How did you manage to produce a fine-crafted book selling for such an inexpensive price?

 Jace arrived at a single-signature catalog structure with a letterpress cover and translucent end sheets that would be hand sewn together for the binding. This accomplished two things: it reduced the production cost with the printer and gave a beautiful handmade feel to the fit and finish of the piece. The guts, or text block, were offset printed in duotone with a tinted spot varnish, essentially a tritone. It's a very simple, elegant design, and the final object feels expensive and unique. The project had so many moving parts, and I am deeply thankful for the generous contributions of my collaborators. The book has also found its way into many notable collections, including the Amon Carter Museum and the Wittliff Collection at Texas State University. It's a thrill.

Fairgrounds
(Cloverleaf Press, 2008)

When self-publishing, for better or worse, you have a hand in every part of the decision-making and production process. Take us through your selection of materials and all that went into making the final book.

Selecting materials for a project like this is one of my favorite parts and we went through many samples looking for the perfect complement of textures and colors. The cover stock is by Neenah Papers and was chosen for its rich tone and compatibility with the letterpress process. The *Fairgrounds* cover illustration is one of my images that I scanned and then rendered as a hard silhouette to reproduce as a graphic icon. Bradley Hutchinson is a master letterpress printer who Jace often works with, and he used two ink colors on the cover to convey depth as well as subtly reference the split toning in my gelatin-silver photographs.

The offset printing was done on a Heidelberg press at CSI Printing in Austin, so that Jace and I could be on hand to oversee the print run. I did the scanning and prepress work, and Paul Barnes at CSI handled the final separations. They were wonderful! I brought my copy of the Nazraeli Press title, *Ratcliffe Power Station* (2004) by Michael Kenna to Paul as a benchmark for the tonalities we were looking for, and he exceeded all expectations. The press sheets were cut, scored, and collated but not punched for binding, a detail we would tend to later.

The final assembly was fairly straightforward. The cover, endsheets, and text block were ganged together and trimmed to the final size of 9.5 x 9.5 inches one at a time. Jace built a jig into which we then loaded the grouped sheets to be punched for sewing. Black linen thread was then used to hand stitch the pieces together, and a tiny spot of glue was placed on the exposed knot to finish. We chose to leave the tied knot on the outside, incorporating its anatomy as another small detail.

CASE STUDY 7: JOHN GOSSAGE

The Pond and *Stadt Des Schwarz*

Twenty-five years after *The Pond* (Aperture, 1985), was published, it is being slightly enlarged and reissued by Aperture, the originating publisher. John Gossage revisits his early experiences with conceiving and creating photography books and the challenging task of bringing depth and dimension to the printed page.

DH & MVS: The Pond *was your first book. How did it come about?*
JG: It was published with Aperture. I worked with the late Carole Kismaric, who was very unique and someone I miss deeply. She looked at the work and said, "This is a really tough book. I don't know what we can do with it." We used to have meetings at her apartment. Aperture basically turned it down at first but then was convinced to take it on.

The Pond *is a very nontraditional photography book. Most people have no idea what to make of it! What was your concept behind it?*
 I had been thinking a great deal about books—all books in general. I was an avid reader, and I was being literary about my approach to photography. The only literary photography book I had really encountered was *American Photographs* (Museum of Modern Art, 1938) by Walker Evans, even more so than Robert Frank's *The Americans* (Grove Press, 1959). Evans was so steeped in literature, he really did quite a dance to avoid the literary model and try to find a photographic-literary model, even way back then. I was very interested in the concept of a "narrative landscape," precisely because it doesn't work in literature.
 For *The Pond*, I thought, "All right, we're going to take a little walk. We're going to step off the pavement, and we're going to walk through these intermediate

The Pond
(Aperture, 1985)

spaces between city and suburb, and then we're going to go home. And it's going to be a fiction. There is no documentary function going on here—the photographs don't necessarily connect, except how I connect them in the book."

They don't stand in as a document of a place that exists, in other words. That's a very revealing statement, given the fact that you're using the visual tropes of documentary photography of the time—black-and-white images, handheld camera, a somewhat loose shooting style.

Exactly. I needed a name for it too. Growing up, I attended the Walden School in Vermont. Thoreau's ideas about the function and relationship of nature to the human psyche were very prevalent there. Without going too deeply into it, I thought it was an interesting philosophy, and I felt it had become undervalued in contemporary society, particularly in the happenstance natural settings that most urban people experienced. There are so many pockets of nature adjacent to cities, just as the historical Walden Pond exists very close to Boston, but people weren't engaging with those spaces in a conscious way.

The pond that is in the book, I had stumbled upon on the way to teaching at the University of Maryland, and it lay behind the Queenstown Shopping Center in Queenstown, Maryland. It was this unique, odd place. I didn't know why it was there, to be honest. It has just sat there unattended, disconnected, and untouched.

Ultimately, *The Pond* is about the environment, about where I lived. I grew up in Staten Island in New York, and I've never been rural in my sensibility. This inter-mediate space of the pond in the book is a place I understood. It was almost like the places where I had played as a child.

John Gossage **THE POND**

In terms of the production and the editing of the book, how did you come up with the final count and selection? Was it something that revealed itself to you as you produced the work, or did you sort through dozens or hundreds of photographs after the fact?

It was still a broad concept at first. I had a few pictures, obviously. I had a very amorphous skeletal structure of the book in my head, and it developed as I went along. Three of the pictures are actually taken in Berlin, but it didn't matter because it was about creating a world within the book. Remember, this is not documentary photography. I mean *The Pond* is a documentary in the same way Evans produced a world. Although Evans's book seems to be a book documenting the 1930s, it isn't—it is a fiction. Evans isn't portraying the world that was going on but how he wanted to portray it—he basically owns that time period now. In the same way, Frank will utterly own the 1950s as we move farther from it. The world they created in their books has supplanted the world that actually existed. That's much, much more ambitious than *The Pond*. *The Pond* was a starter book. I wanted to do something simple and do it as well as I knew how.

How many photographs are in The Pond?

Forty-nine. There will be fifty-two in the reprint because there were three pictures that I couldn't fit into the first edition because of financial reasons.

So this is the director's cut. Brilliant.

Yes. Now I'm trying to figure out where they go in the sequence because the current sequence is so ingrained in me. I think I can make it work, but right now they don't want to go anywhere!

Your next book was Stadt Des Schwarz *(Loosestrife Editions, 1987), another nontraditional photography book that was radically different, in appearances, from* The Pond. *Conceptually, where did you start?*

This was just a few years later, in 1987 I think. Every book I've done has been in response to the circumstances of my life at the time. I was shooting in Berlin, and a dear friend, Katie Jones, loved the "black" photographs I was making—they were very dark and had few white highlights. I had no intention at the time of publishing them until much later, but she loved them. She was dying of cancer and wanted to see them as a book. I gave her a set of photographs for her collection, but she just told me to do the book exactly as I wanted and offered to pay for it. So we did five hundred copies with no distribution at all. The $50 retail cost was far below the actual production costs. We tipped an original print on the cover, and it was the first of the "big" trim size books that so many photography publishers have done now.

If I remember right, the photographic tones are mostly between 92 percent black and 100 percent black; the German printer for the job had a helluva time. They had to completely recalibrate the laser scanner for that much ink. It was one of the first digital scanners, and initially, it couldn't read the difference between 92 percent and 100 percent black, which is where all of the tones for the images reside. The first proofs were all very muddled blacks.

In the book, I didn't want the images facing each other on the page spread, so we decided to put an acetate tissue in between the images to separate them and to keep the printing costs down. Even though the production costs were essentially paid for, we still had a limited amount of money. I think the whole thing cost about $14,000.

Stadt Des Schwarz: Eighteen Photographs of Berlin
(Loosestrife Editions, 1987)

How many photographs are reproduced?

Eighteen, plus the one on the cover, which comes to nineteen. These were all really big prints. I thought it would be really easy after I made the first two images, but conceptually the work was really hard.

You have said that the photographs are really about volume. But the images are so dense and elusive. We often associate volume with empty space. Can you talk about what you meant by that comment?

Well, I wanted to photograph darkness at night. Most night pictures are about the lights at night.

That's true. They're about the low light or the points of light but nevertheless still about the light.

Exactly. Because of the nature of how the wall ran through the center of Berlin, there was a band of darkness. You know, the wall was actually made of two walls, and the area between the two was only partially lit. The western wall, as they've called it, was still actually in East Germany. The government didn't allow the wall to be built in the western side, so they created this "exempt" area. But it's still actually built a fair distance into the eastern part, so it could be repaired if necessary. Anyway, the walls and the space between varied in distance depending on what part of the city you were in. If you flew over it at night, there were well-lit areas filled with security lights, and there were portions that made the wall seem like a band of darkness that ran through the entire city. It was fascinating. I'd never seen anything like it in an urban space.

The wall made me really fascinated with darkness as a physical entity. I had studied photography with Lisette Model, and one of her big things was to photograph fat people. She was really big about volume, and she embedded that appreciation in her students. I remember that she would always make the bottom of her prints dark. She would burn them in to give them something to "stand on," as she would say, so that they had weight, so they didn't float away.

That's a wonderful explanation!
And it is one of these things you never consider or even understand when you're very young. But it stayed with me and came back to me during this project.

So here you are photographing darkness as volume, which seems nonsensical.
　　Right.

And then showing us volume on a two-dimensional plane—also nonsensical, in that volume, by definition, is about three dimensions in space.
　　Correct. But perversely, the black photographs are the most present photographs in that they utilize all the silver salts. Basically, light tones are the elimination of what has been put on the paper.

Yes! You're right. They are the weightiest photographs in a literal sense—more silver for your buck! This is one of the most amazing aspects of photography, that a two-dimensional image (and a mostly two-dimensional object) can convey something like volume, which is contrary, or at least outside of, the realm of the notion of two dimensions.

Exactly. That it can be about weight when the object itself is totally ephemeral. It's just a little thin piece of paper. So I knew I had to have a big book. That was a given. Nobody was making big books like this at the time, so the first thing we had to figure out was how big of a sheet size we could print on with the printing presses. I forget where exactly, but we had to ship all the sheets to this amazing bindery in rural Germany somewhere. I think it was an old dairy farm, and all of these women were hand making the books. It was like a medieval scene. But it came out beautifully.

In terms of the idea around which the book revolves, you surely didn't arrive in Berlin and say, "Oh, this project will be about volume." What was the refinement process that led to that idea?

It was my first book on anything foreign. I didn't understand what I was photographing at first, on a certain level, which is a way of admitting my failings. With *The Pond*, I understood it instinctually: it's my place, it's where I played as a child, if you will.

Are you finished with book making?

Oh God no. I've done fifteen publications. I'm definitely not done. They are such a rich form of expression.

6

Resources, Appendices, and Worksheets

Appendix I: Anatomy of a Book

FRONT MATTER

 Half-Title and Title Page

 Copyright Page

 Dedication

 Table of Contents

 Foreword, Preface, and/or Introduction

EDITORIAL CONTENT

 Your Photographs!

 Contributor Essays and Interviews

BACK MATTER

 Acknowledgments

 Plate List and Captions

 Chronology

 Selected Exhibition History

 Awards

 Bibliography

 Biography

 Index

This list includes various possible components of a photo book. Your book will include some or all of these.
For a full list of terms and their definitions, see www.alibris.com/glossary/glossary-books

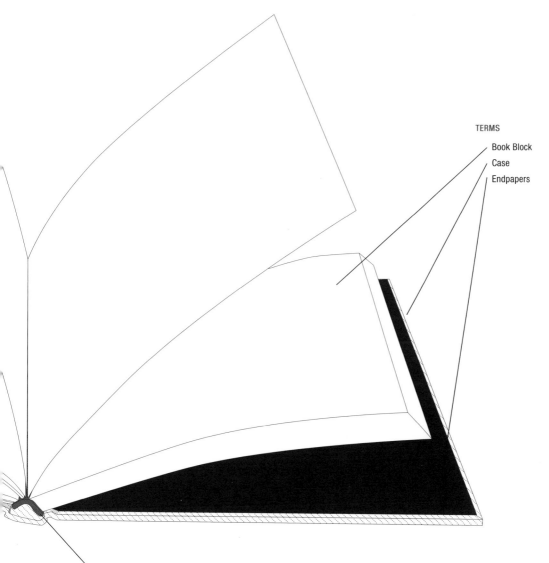

TERMS

Book Block

Case

Endpapers

Head & Tail Bands

Timeline I: Design and Production

ONE YEAR BEFORE	10 MONTHS	9 MONTHS	8 MONTHS

Initial design concept from designer.

Finalize and approve design concept.

Confirm agreement with printer, binder, and the shipping agent.

Work with pre-press house on digital files for reproduction.

Research other photography books for preferences on design and materials, including trim size, binding method, type of reproductions, cover cloth, and paper.

Edit images toward final selection.

Determine text elements, possibly including a foreword, essay, caption list and any other back matter.

Secure commitments from contributor(s).

Contact and interview designer(s).

Order ISBN number(s).

Submit final manuscript and artwork to designer.

Deliver preliminary materials to designer for design concept.

Secure bids from printers, binders, and shipping agents (often a single business will handle all three of these aspects).

7 MONTHS	5 MONTHS	3 MONTHS	1 MONTH	BOOK LAUNCH!

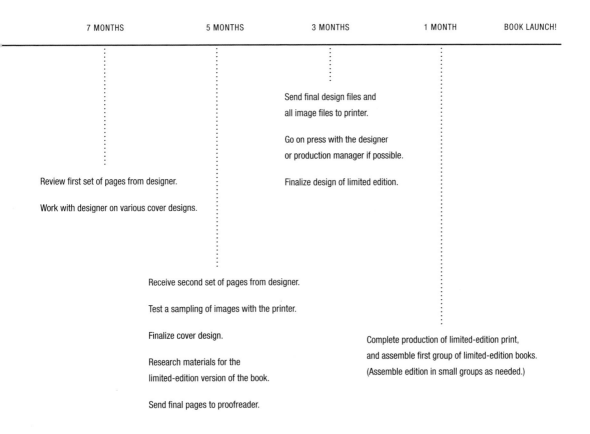

Send final design files and
all image files to printer.

Go on press with the designer
or production manager if possible.

Finalize design of limited edition.

Review first set of pages from designer.

Work with designer on various cover designs.

Receive second set of pages from designer.

Test a sampling of images with the printer.

Finalize cover design.

Research materials for the
limited-edition version of the book.

Send final pages to proofreader.

Complete production of limited-edition print,
and assemble first group of limited-edition books.
(Assemble edition in small groups as needed.)

ᴵ This is a general timeline for design and production issues related to a book. We have crafted the outline as though you are self-publishing, and therefore all aspects of the book would be your responsibility. Working with a publisher implies following the schedules that they set, which may differ from this outline.

Timeline II: Marketing

| EARLY PLANNING | ONE YEAR BEFORE | 9 MONTHS | 6 MONTHS |

Purchase the ideal Internet URL, blog, and twitter titles toward promoting brand identity.

Begin to gather names for mailing list: press contacts, bookstores, special groups, and possible exhibition venues.

Introduce your photographs to industry professionals at portfolio-review events.

Begin relationships with those who can guide you toward exhibitions and publication.

Document the "making of" process of your publication for future PR and marketing purposes.

Establish graphic branding for marketing tools based on cover design or signature imagery.

Approach targeted venues for exhibitions.

Begin to gather lists of venues for book signings.

Establish web presence.

Begin to establish presence on subject-related blogs.

Begin to research PR and marketing practices, paying attention to comparable book campaigns.

Begin contacting venues for book signings upon release.

Begin to produce branded press materials.

Research cost of placing targeted ads during launch.

Research costs of creating a short (2–5 minute) digital-video profile on you and your publication.

This is a general timeline for marketing and publicity issues related to a book. We have crafted the outline as though you are self-publishing, and therefore all aspects of the book would be your responsibility. Working with a publisher implies following the schedules that they set, which may differ from this outline.

| 3 MONTHS | 1 MONTH | BOOK LAUNCH! | BEYOND BOOK'S RELEASE |

Update website and blog with news and photographs of public appearances and signings.

Deliver all press materials, including images, information, testimonials ("blurbs"), personal profiles, and headshots of yourself and any contributors, to any PR professionals involved in your publication.

Collaborate closely with PR professionals to reach all targeted members of the press.

Make yourself available for all opportunities to promote your book.

Keep your book in the public eye!

Submit applications for relevant conferences, as well as events that draw an audience interested in the subject area of your book.

Begin promotion to press outlets that require three-month advance submission for listings and consideration of feature story ("serial rights").

Submit book to publication and industry award competitions.

Compile all press received and cull them for testimonials.

Confirm all venues for book signings and exhibitions.

Continue to document public appearances.

Finalize list of book reviewers — including key print, TV, radio, and online publications.

Update your website's news, calendar, and press pages.

Pursue profiles in the press on you and your publication.

Continue to research and secure additional book signing venues, both local and national.

Expand website content with calendar of related events.

Continue to research and secure additional exhibition venues, both local and national.

Begin mailing announcements to broad list(s) covering all targeted audiences.

Worksheet I: Preparing for Your Book

Ask yourself these questions before beginning the publishing process:

Why do you want a book of your photographs?

...

...

Describe your proposed book in one sentence:

...

Describe your proposed book in one paragraph:

...

...

...

...

What is left to do and when do you anticipate completing your project?

...

Are there any titles currently in print that could be considered competitive with your book?

...

...

...

Who would be an ideal contributor(s) to your book?

...

...

Which publishers should you target or would be a good match for your project and why?

...

...

...

Describe and quantify the current audience for the project.

...

...

...

...

Who is the desired audience for this book, and how can you best reach them?

...

...

...

...

On a separate sheet of paper, list your three favorite photography books and why.

On a separate sheet of paper, list your three least favorite photography books and why.

Appendix II: Publishers

5 Continents Editions www.fivecontinentseditions.com

12th Press www.12thpress.com

21st Editions www.21stphotography.com

A-Jump Books www.a-jumpbooks.com

Abrams www.abramsbooks.com

Actar www.actar.es

Actes Sud www.actes-sud.fr

AMMO Books LLC www.ammobooks.com

Apeiron Photos www.apeironphotos.com

Aperture Foundation www.aperture.org

Archive of Modern Conflict www.amcbooks.com

Assouline www.assouline.com

Balcony Press www.balconypress.com

Bildschöne Bücher www.bildschoene-buecher.de

Center for American Places www.americanplaces.org

Charles Lane Press www.charleslanepress.com

Charta Books Ltd. www.chartaartbooks.it

Chris Boot Ltd. www.chrisboot.com

Chronicle Books www.choniclebooks.com

Cloverleaf Press www.cloverleafpress.com

Codax Publisher www.codax-publisher.com

Contrasto www.contrasto.it

Damiani Editore www.damianieditore.it

DECODE Books www.decodebooks.com

Dewi Lewis Publishing www.dewilewispublishing.com

Duke University Press www.dukeupress.edu

Edition Kamel Mennour www.kamelmennour.fr

Edition Patrick Frey www.editionpatrickfrey.ch

Éditions Xavier Barral www.exb.fr

Editorial RM www.editorialrm.com

episode publishers www.episode-publishers.nl

errata editions www.errataeditions.com

Fotofolio www.fotofolio.com

Gingko Press Inc. www.gingkopress.com

Godine www.godine.com

Hassla www.hasslabooks.com

Hatje Cantz Verlag www.hatjecantz.de

Hol Art Books www.holartbooks.com

Holzwarth Publications GmbH www.holzwarth-publications.de

The Ice Plant www.theiceplant.cc

J&L Books www.jandlbooks.org

JOVIS Verlag GmbH www.jovis.de

JRP|Ringier Kunstverlag AG www.jrp-ringier.com

Kehrer Verlag www.artbooksheidelberg.de

Kerber Verlag Bielefeld www.kerber-verlag.de

KesselsKramer Publishing www.kesselskramerpublishing.com

Kurimanzutto www.kurimanzutto.com

Lars Müller Publishers www.lars-mueller-publishers.com/en

Little More www.littlemore.co.jp/en

Lodima Press www.lodimapress.com

Loosestrife Editions www.loosestrifebooks.com

Lumiere Press www.lumierepress.com

MB Editions www.modernbook.com

Merrell Publishers Limited www.merrellpublishers.com

Michael Lett www.michaellett.com

The MIT Press www.mitpress.mit.edu

The Monacelli Press www.randomhouse.com/monacelli

Museum of New Mexico Press www.mnmpress.org

National Geographic Books http://books.nationalgeographic.com

Nazraeli Press www.nazraeli.com

Peliti Associati www.pelitiassociati.com/casaeditrice/

Phaidon Press Limited www.phaidon.com

The Philidor Company www.philidor.com

Photology www.photology.com

Pond Press www.pondpress.com

powerHouse Books www.powerhousebooks.com

PPP Editions www.andrewroth.com

PQ Blackwell www.pqblackwell.com

Prestel www.prestel.de

Princeton Architectural Press www.papress.com

Princeton University Press www.press.princeton.edu

The Quantuck Lane Press www.quantucklanepress.com

Radius Books www.radiusbooks.org

Rizzoli www.rizzoliusa.com

Schaden www.schaden.com

Schilt Publishing www.schiltpublishing.com

Schirmer/Mosel Publishing www.schirmer-mosel.de

Smithsonian Books www.smithsonianbooks.com

Stanford University Press www.sup.org

Steidl www.steidlville.com

TASCHEN GmbH www.taschen.com

teNeues Publishing Company www.teneues.com

Thames & Hudson www.thamesandhudson.com

Timezone 8 www.timezone8.com

Torst www.torst.cz

Trans Photographic Press www.transphotographic.com

Trinity University Press http://tupress.trinity.edu

Trolley Books www.trolleybooks.com

Twin Palms Publishers/Twelvetrees Press www.twinpalms.com

Umbrage Editions www.umbragebooks.com

University of California Press www.ucpress.edu

University of Minnesota Press www.upress.umn.edu

University of New Mexico Press www.unmpress.com

University of Texas Press www.utexas.edu/utpress

University Press of Mississippi www.upress.state.ms.us

Verve Editions www.verveeditions.com

W. W. Norton & Company Inc. http://books.wwnorton.com/books

Yale University Press http://yalepress.yale.edu

Appendix III: Distributors

ActarBirkhäuser D www.actar-d.com

Consortium www.cbsd.com

D.A.P./Distributed Art Publishers www.artbook.com

Fotofolio www.fotofolio.com

Idea Books www.ideabooks.nl

Ingram Book Company www.ingrambook.com

Independent Publishers Group www.ipgbook.com

The Perseus Books Group www.perseusbooksgroup.com

r.a.m. publications + distributions inc. www.rampub.com

Textfield Inc. www.textfield.org/distribution

For a list of international book distributors,
see the directory at the PublishersGlobal website. www.publishersglobal.com

Appendix IV: Independent Bookstores and Dealers

In addition to these booksellers, many museums and arts institutions have bookstores.

BOOKSTORES

192 Books, New York City www.192books.com

Amazon www.amazon.com

Ampersand, Portland, OR www.ampersandvintage.com

Aperture Gallery and Bookstore, New York City www.aperture.org/gallery

Arcana, Santa Monica, CA www.arcanabooks.com

Argentic, Paris www.argentic.fr

Art Metropole, Toronto www.artmetropole.com

Boekie Woekie, Amsterdam www.xs4all.nl/~boewoe/frame2.htm

Books & Books, various locations www.booksandbooks.com

Booksoup, Hollywood, CA www.booksoup.com

Buchhandlung Walther König, Cologne www.buchhandlung-walther-koenig.de

Claire de Rouen Books, London www.clairederouenbooks.com

Clic Bookstore & Gallery, New York City and various locations www.clicgallery.com

Dashwood Books, New York City www.dashwoodbooks.com

Dawson's Bookshop, Los Angeles www.dawsonsbooks.com

Deichtorhallen Hamburg GmbH, Hamburg www.deichtorhallen.de

Dawson's Bookshop, Los Angeles www.dawsonbooks.com

Dia Books, Beacon, NY www.diabooks.org

Family, Los Angeles www.familylosangeles.com

Glenn Horowitz Bookseller, East Hampton, NY www.ghbookseller.com

John McWhinnie @ Glenn Horowitz, New York City www.johnmcwhinnie.com

Harper's Books, East Hampton, NY www.harpersbooks.com

Hennessey + Ingalls, Santa Monica, CA www.hennesseyingalls.com

International Center of Photography, New York City www.icp.org/store

iTunes Bookstore http://itunesconnect.apple.com

KK Outlet, London www.kkoutlet.com/shop/kk-publishing

Kowasa, Barcelona www.kowasa.com/eng

LeadApron, Los Angeles www.leadapron.net

marcus campbell art books, London www.marcuscampbell.co.uk

The Magnum Store, New York City http://store.magnumphotos.com

Moe's Books, Berkeley, CA www.moesbooks.com

MoMA Store, New York City www.momastore.org

Ooga Booga, Los Angeles www.oogaboogastore.com

Photo Books International, London www.pbi-books.com

photo-eye Bookstore, Santa Fe www.photoeye.com

PHG BOOKSTORE, Vancouver www.presentationhousegall.com

Powell's Books, Portland, OR www.powells.com

Printed Matter Inc., New York City www.printedmatter.org

Schaden.com, Cologne www.schaden.com

Spoonbill & Sugartown, Brooklyn, NY www.spoonbillbooks.com

St. Mark's Bookshop, New York City www.stmarksbookshop.com

Strand Bookstore, New York City www.strandbooks.com

Tattered Cover Book Store, Denver www.tatteredcover.com

William Stout Architectural Books, San Francisco www.stoutbooks.com

Wittenborn Art Books, San Francisco www.art-books.com

Whelan Photography Books, Portland, ME photobks@midcoast.com (email)

Ursus Books and Prints, New York City www.ursusbooks.com

Utrecht, Tokyo www.utrecht.jp

Warwick's, La Jolla, CA www.warwicks.indiebound.com

Lists of independent bookstores can be found at these links:
Note: not all links featured with these lists have been verified; further research recommended.

http://newpages.com/bookstores

www.indiebound.org

www.bookweb.org/aba/members/browse.do

BOOK DEALERS

Andrew Cahan: Bookseller Ltd., Akron, OH www.cahanbooks.com

Bibliophoto, Paris www.bibliophoto.com

Dirk Bakker Books, London www.dirkbakkerbooks.com

Division Leap, New York City www.divisionleap.com

Edition Patrick Frey, Zurich, Switzerland www.editionpatrickfrey.ch

FOIL Books, Tokyo www.foiltokyo.com

Gary Saretzky PhotoBooks, Tennent, NJ www.saretzky.com

IF libri, Milano, Italy www.iflibri.it

Irving Zucker Art Books, New York City. www.zuckerartbooks.com

LENDROIT, Rennes, France www.lendroit.org/lendroit/index.php?id=1

Luïscius Antiquarian Booksellers, 's-Hertogenbosch, The Netherlands www.luiscius.com

ModernRare, Chicago www.modernrare.com

Motto Distribution, Assens, Switzerland www.mottodistribution.com/site

Panorama Web Shop, Tokyo http://shop.pnrm.jp

Pawprint Books, Oradell, NJ www.pawprintbooks.com

PhotoBookStore, Kent, United Kingdom www.photobookstore.co.uk

photo-eye Auctions, New York City www.photoeye.com/Auctions

Phototitles Limited, Osgodby, United Kingdom www.phototitles.com

PPP Editions, New York City www.andrewroth.com

Teeluxe Studio, Ewingsdale, Australia http://teeluxe.com.au

Timothy Whelan Photography Books photobks@midcoast.com (email)

TTC Gallery, Copenhagen www.ttcgallery.com

Vamp & Tramp Booksellers, Birmingham, AL www.califiabooks.com

Vincent Borrelli, Bookseller, Albuquerque, NM www.vincentborrelli.com

Woodfinch Rare Books, London www.simonfinch.com

Yebisu Art Labo, Nagoya, Japan www.artlabo.net

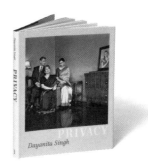

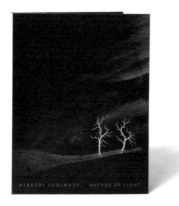

A selection of contemporary books that represents
the diversity of photobook publishing today:

Joel Sternfeld, *Walking the High Line* (Steidl, 2001)

Cuny Janssen, *Macedonia* (Schaden.com, 2003)

Stephen Gill, *Hackney Wick* (Nobody, 2005)

Joakim Eskildsen, *Nordtegn, Nordic Signs* (self-published, 1995)

Dayanita Singh, *Privacy* (Steidl, 2003)

Hiroshi Sugimoto, *Nature of Light* (Nohara, 2009)

Appendix V: Festivals, Awards, and Trade Events

We encourage you to research and attend local, national, and international book fairs
and to enter book competitions to help bring more attention to your book.

PHOTOGRAPHY BOOK FESTIVALS AND AWARDS

The Arles Contemporary Book Award www.rencontres-arles.com

The Art Book Award www.blackwellpublishing.com/pdf/artbook_award_2007.pdf

The Best Photobook of Latin America www.editorialrm.com/concurso/first.html

Dummy Award www.fotobookfestival.org/en/dummyprize/

European Publishers Award for Photography www.dewilewispublishing.com

Festival of Light www.festivaloflight.net

International Photobook Festival, Kassel, Germany www.fotobookfrestival.org/en/start/

Fotobuch-tage, Photobook Days, Hamburg, Germany www.fotobuch-tage.de

George Wittenborn Award www.arlisna.org/about/awards/wittenborn_info.html

The getPublished Award, Art Book Hamburg www.artbookhamburg.de/en/6/getpublished-award.html

Honickman First Book Prize in Photography www.cds.aas.duke.edu/bp/index.html

The Kasseler Photobook-Festival www.kasselerfotoforum.de

Le Garage www.legarage.cc

Lens Culture/Rhubarb Photo Book Award www.lensculture.com

Los Angeles Times Book Prizes http://events.latimes.com/bookprizes/overview/

The New York Photo Festival Awards www.nyphotofestival.com

PDN Photo Annual www.pdnphotoannual.com

Photography Book Now http://pbn.blurb.com/awards

TRADE EVENTS

BookExpo America www.bookexpoamerica.com

Digital Book World www.digitalbookworld.com/conference

Editions|Artists Book Fair www.eabfair.com

Frankfurt Book Fair www.buchmesse.de/en/networking/fairs_markets/

The Independent and Small Press Book Fair http://nycip.wordpress.com/about/

Library of Congress National Book Festival www.loc.gov/bookfest

London Art Book Fair www.londonartbookfair.com

New York Art Book Fair, co-sponsored by Printed Matter www.nyartbookfair.com

For a listing of book festivals: www.bookfestivals.com

The Art Libraries Society of North America (ARLIS) maintains a calendar of upcoming
book awards, conferences, and other events on their website http://arlisna.org/news/calendar.html

Appendix VI: Blogs and Book Arts Resources

PHOTOGRAPHY BOOK BLOGS

5b4 Photography and Books www.5b4.blogspot.com

afterart news www.afterartnews.com

AM BRUNO www.am-bruno.blogspot.com

BINT photoBooks on INTernet www.bintphotobooks.blogspot.com

Blurberati Blog http://blog.blurb.com

Broken Spine http://brokenspine.zacharysallen.com

buffet www.andrew-phelps.blogspot.com

Darius Himes http://dariushimes.com/

The Independent Photo Book www.theindependentphotobook.blogspot.com

Japan-Photo.info www.japan-photo.info/blog

Little Brown Mushroom Blog www.littlebrownmushroom.wordpress.com

The PhotoBook www.thephotobook.wordpress.com

Print Fetish www.printfetish.com

RESOLVE www.blog.livebooks.com

PUBLISHING INDUSTRY RESOURCES

American Booksellers Association www.bookweb.org

Art Libraries Society of North America www.arlisna.org

BookExpo America www.bookexpoamerica.com

Bookwire www.bookwire.com

Center for Independent Publishing http://nycip.wordpress.com

Center for the Book in the Library of Congress www.read.gov/cfb

Copylaw www.copylaw.org

Copyright Clearance Center www.copyright.com

Digital Book World www.digitalbookworld.com

Digital Library Federation www.diglib.org

The Future of Publishing www.thefutureofpublishing.com

Independent Book Publishers Association www.pma-online.org

Independent Publisher www.independentpublisher.com

Indie Bound www.indiebound.org

International Digital Publishing Forum www.idpf.org

JacketFlap www.jacketflap.com

Permanence Matters www.permanencematters.com

Publishers Lunch www.publishersmarketplace.com/lunch/free/

The PW Morning Report blogs.publishersweekly.com/PWxyz

Small Publishers Assoc. of North Am. www.spannet.org

PUBLISHING INDUSTRY BLOGS AND PODCASTS

Book Expo America www.bookexpocast.com

Covering Photography www.coveringphotography.com

Digital Book World www.digitalbookworld.com/category/webcasts

GalleyCat www.mediabistro.com/galleycat

Idea Logical Blog www.idealog.com/blog

Jacket Copy http://latimesblogs.latimes.com/jacketcopy/

Joe Wikert's Publishing 2020 Blog www.jwikert.typepad.com

Pete Alcorn TED talk www.ted.com/speakers/pete_alcorn.html

Publetariat: People Who Publish www.publetariat.com

Publishing Trends http://publishingtrends.blogspot.com

The Self Publishing Blog www.self-publishing.us

Talking New Media www.talkingnewmedia.blogspot.com

ARTIST'S BOOK RESOURCES

ABC Artists' Books Cooperative www.abcoop.wordpress.com

Acme Bookbinding www.acmebook.com

Andrew Eason: Artist's Books www.andreweason.com

Art, Books, and Creativity www.artbookscreativity.org

Artist Book Database www.artistbookdatabase.org

Artist Book News www.artistbooknews.com

Artist Books 3.0 www.artistbooks.ning.com

Artists' Books Online www.artistsbooksonline.org

Artists' Books: Strategies for Collecting www.rarebookschool.org/reading/collecting/c80/

Ball Peen Bindery www.ballpeenbindery.com

The Book Arts Forum www.bookartsforum.com

Book Arts Guild www.bookartsguild.org

Book Arts Web www.philobiblon.com

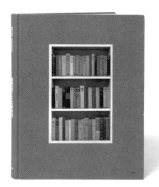

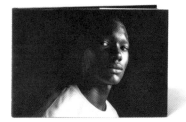

A selection of contemporary books that represents
the diversity of photobook publishing today:

Marc Joseph, *New & Used* (Steidl, 2006)

Norman Mauskopf, *A Time Not Here* (Twin Palms, 1996)

Geert van Kesteren, *Why Mister, Why?* (Artimo, 2004)

Paul Graham, *A Shimmer of Possibility* (Steidl, 2007)

Joan Fontcuberta, *Sputnik* (Fundacion Arte y Tecnologia, 1997)

Roy Decarava, *The Sound I Saw* (Phaidon, 2001)

Book Lab II www.bookways.com

Booklyn www.booklyn.org

Canadian Bookbinders and Book Artists Guild www.cbbag.ca/home.html

Center for Book Arts www.centerforbookarts.org

Centre for Fine Print Research Book Arts Newsletter www.bookarts.uwe.ac.uk

Ellen Lupton "Indie Publishing" www.papress.com

Erinzam News www.erinzam.com/blog

Esther K. Smith "How to Make Books" www.purgatorypiepress.com

George Bayntun Fine Bindings and Rare Books www.georgebayntun.com

Granary Books www.granarybooks.com

International Society of Altered Book Artists (ISABA) www.alteredbookartists.com

Jenni Bick Bookbinding www.jennibick.com

The Journal of Artists' Books www.journalofartistsbooks.org

Keith A. Smith "Bookbinding for Book Artists" www.keithsmithbooks.com

Minnesota Center for Book Arts www.mnbookarts.org

Nicole Anderson Book Arts www.nabookarts.com

Pacific Center for the Book Arts www.pcba.info

Printed Matter www.printedmatter.org

Priscilla Jurvellis Inc. (book dealer) www.juvelisbooks.com

Pyramid Atlantic Art Center www.pyramidatlanticartcenter.org

Quercus Press www.quercuspress.com

San Francisco Center for the Book www.sfcb.org

Scott McCarney Visual Books www.scottmccarneyvisualbooks.com

Seattle Center for Book Arts www.seattlebookarts.org

Shelter Bookworks www.shelterbookworks.com

Visual Studies Workshop www.vsw.org

We Make Zines www.wemakezines.ning.com

Appendix VII: Submission Requirements

These guidelines are compiled from our experiences working with various publishers and by turning directly to the submission requirements as posted on a variety of publishers' websites. Different publishers will have different guidelines, but generally you should keep in mind the following advice: The review process usually takes at least three months, and you may not receive a personalized response to unsolicited proposals. Some publishers have specific dates for when they review submissions, so if you submit early, your submission may not be returned to you for several months. Due to the large number of submissions publishers receive, many will not return materials. Never send original material unless otherwise requested to do so. Publishers often specifically request that submissions be delivered only by mail or email. Always be sure to follow the publisher's stated submission guidelines carefully.

What to include in your submission packet:

A one-page cover letter, stating why you think this particular publisher should be interested in your manuscript. Include your contact information and a list of the package contents.

A brief one-page synopsis of the work.

One page Curriculum Vitae or professional summary.

A summary of target audience(s) for the book and how to reach them.

A list of competing or similar titles currently in print from other publishers.

A short personal biography as well as those of any contributing author/photographer. Indicate if the contributors have been confirmed.

Samples of the work: color laser copies, digital prints, or a CD with images in a slide show format or as PDFs, as specified by the publisher's guidelines.

A self-addressed, stamped envelope for return of materials or for confirmation of receipt of materials, if indicated within guidelines.

Appendix VIII: Online Marketing Resources

There are a wealth of resources and articles online about marketing books:

ON UNDERSTANDING ELEMENTS OF DESIGN AND BRANDING

AIGA Design Archives www.designarchives.aiga.com

AIGA Why Design? http://designarchives.aiga.org/#/home

AIGA Case Studies www.designing.aiga.org

Steven Heller (podcasts and more) www.hellerbooks.com/docs/podcasts.html

Ellen Lupton www.papress.com/other/thinkingwithtype/

ON THE BUSINESS OF PUBLISHING

Bauu Institute and Press www.bauuinstitute.com/Marketing/Marketing.html

Book Catcher, online publishing resources www.bookcatcher.com

Center for Independent Publishing. www.nycip.org/resources/publishing_articles.php
("Publishing Resources")

David Airey www.davidairey.com/top-50-graphic-design-blogs/
("50 Top Graphic Design Blogs")

John Kremer www.bookmarket.com/downloads.htm
("Free downloadable Books, Reports and Other Files in PDF, HTML or Doc Formats.")

Mark Hurst www.goodexperience.com/2008/07/following-up-on-these.php
("Secrets of Book Publishing I Wish I'd Known")

Seth Godin www.sethgodin.typepad.com/seths_blog/2006/08/advice_for_auth.html
("Advice for Authors")

Shannon Wilkinson www.culturalcommunications.info/newsletter.html
("Art PR: Then & Now")

Wheatmark www.wheatmark.com/index.php?/resources
("Resources for Self-Published Authors")

Acknowledgments

When we sat down for a break during the Society for Photographic Education (SPE) conference in Newport, Rhode Island, in 2003 to draft an outline for a series of articles titled "Publishing the Photobook" that would run in *photo-eye Booklist*, we knew that we had the makings of a book. We are first and foremost grateful to Rixon Reed, the owner and director of photo-eye, for encouraging the column from the very beginning. The column ran for a total of twelve installments over three years (2004–7) and was a recurring topic of conversation among photographers wherever we went. It was timely then, and even more so now.

DH: I am indebted to my parents for instilling in my siblings and me a great love of books. Quite simply, the regular act of reading aloud as a family did more to foster this passion than anything else. The professors at the School of Art at Arizona State University contributed greatly to give me a sense of place within the photographic tradition, both historically and creatively. Bill Jay, William Jenkins, Mary Anne Redding, James Hajicek, and John Risseeuw all deserve mention here. My time at St. John's College in Santa Fe became the place where, intellectually, I trained for a life devoted to writing about and defending the arts and the place they must hold in society. The devoted tutors of that Great Books program are giants in their love for books and students.

The nine years I spent at photo-eye—1998 to 2007—in a variety of roles—most notably as editor of the quarterly *photo-eye Booklist*—was invaluable in shaping my perceptions and in driving my devotion to the field. I wouldn't have been able to explore the publishing landscape without the explicit and implicit support of owners Rixon Reed and Vicki Bohannon. And lastly, Mary Virginia Swanson is an

indefatigable supporter of photography and photographers, and I am thankful to have had her support as we pursued this rich and exciting project.

MVS: Books, books, and more books. My love of photography books was sparked by Bill Jay's lectures on the history of photography at Arizona State University. During a semester in London, I spent Fridays at the Royal Photographic Society's office, where I had the opportunity to see many rare titles first hand. Ted Hartwell's curatorial office at the Minneapolis Institute of Arts, where I interned as a graduate student, was home to a great photography library that surrounded me at the perfect time in my early professional life. Colleagues Peter A. Andersen, John Cleary, Daile Kaplan, Dave Gardner, Susan kae Grant, Bruce Gilden, Deborah Bell, Sean Perry, Jim Stone, Lance Speer, Tim Whelan, and Rixon Reed all shared their deep love of photobooks with me.

My collaborator, Darius Himes, and I began our dialogue about books many years ago; it has lead us through three years of jointly authoring a column in the *photo-eye Booklist* and on to coauthor this publication. His excitement about books is infectious; one could not have a more fantastic collaborator. Jennifer Thompson and Linda Lee at Princeton Architectural Press have guided our ideas into print—they have been exceptional teachers. Lastly, many thanks go to my patient family, who lives amidst my ever-expanding library of photography books.

For their contributions to this book, we would like to thank the following people:

The artists in our case studies: John Gossage, Paula McCartney, David Maisel, Sean Perry, Lisa M. Robinson, Alec Soth, Alex Webb, and Rebecca Norris Webb.

All of the folks in the publishing industry that offered their thoughts and voices: Deborah Aaronson, Sam Abell, Greg Albers, Bob Aufuldish, Alexa Becker, Leah Ben-david-Val, Geoff Blackwell, Chris Boot, Frish Brandt, Joan Brookbank, Jane Brown, Gary Chassman, David Chickey, Andrea Danese, Susan Dwyer, Patricia Fidler, Gösta Fleming, Roy Flukinger, Jason Fulford, Gigi Giannuzzi, Eileen Gittins, Markus Hartmann, Joanna Hurley, Daile Kaplan, Mark Klett, Scott-Martin Kosofsky, Jeffrey Ladd, Maria Levy, Michelle Dunn Marsh, Lesley A. Martin, Theresa May, Sue Medlicott, Raymond Meeks, Daniel Milnor, Robert Morton, Kyra Muller, Margery Newman, Martin Parr, Chris Pichler, Daniel Power, Rixon Reed, Ramon Reverte, Nan Richardson, Sara Rosen, David Skolkin, Allison V. Smith, Lance Speer, Dale W. Stulz, Eric Swanson, George Thompson, Jennifer Thompson, Shannon Wilkinson, Jo Whaley, Lorraine Wild, Denise Wolff, and Nancy E. Wolff.

David Chickey and Masumi Shibata for the brilliant book design, and Masumi for his fastidious help with photographing the books and making the image files perfect.

Larissa Leclair for her editorial assistance. Katrina d'Autremont and Lisa Jo Roden for their organizational and research skills. Rixon Reed and Melanie McWhorter of photo-eye Books for loaning copies to be photographed of some of the featured books.

Published by
Princeton Architectural Press

For more information on the books and artists featured in *Publish Your Photography Book*, as well as a calendar of lectures and seminars by Himes and Swanson visit: www.publishyourphotographybook.com